THE
NSDAP CENTRE
in Munich

Edited by the Central Institute for Art History
With an Essay by Klaus Bäumler

DEUTSCHER KUNSTVERLAG

Iris Lauterbach

INTRODUCTION

W ith the 1930 purchase of what would become the "Brown House," the National Socialist Party took the first step in developing the party district at Königsplatz. Starting in 1933, more than 50 buildings along Brienner Straße, Arcisstraße, Gabelsbergerstraße, Barer Straße and Karlstraße, as well as the adjoining streets, came into the ownership of the Nazi Party (see map on inside back cover). While some of these buildings (for example, the Pringsheim House) were demolished to create space for new construction, most of them were retained and put to new uses as offices of various party bureaucracies.

The reconfiguration of Königsplatz with adjacent new construction was the National Socialist Party's first major building project. The "Führer Building" ("Führerbau"), the "Administrative Building of the National Socialist Party" ("Verwaltungsbau der NSDAP") and the two "Temples of Honour" ("Ehrentempel") located along today's Arcis and Katharina-von-Bora-Straße, together with the redesign of Königsplatz, comprised a monumental forum of bureaucratic rule and party cult created for the purpose of manifesting the party's (and, derivatively, the state's) claim to power.

The massive urban intervention radically changed the appearance of the classically-designed square. From the time of its origins, Königsplatz was a meeting place, which since World War I had been favoured by right-wing political groups. The National Socialists extended this tradition of use, shaping it according to their interests. Already, on May 10, 1933, they made the square a stage for a book burning event. Under their rule, the square became a focal point for ceremonial marches and the yearly celebration of their pseudo-religious commemorative cult. The square was inaugurated on November 9, 1935, when the sarcophagi of the "blood witnesses" of Hitler's failed Beer Hall Putsch were transferred to the Temples of Honour. Celebrated annually thereafter, the ritual incorporated the celebrated "Roll Call," which concluded with a loud acclamation

("Present!") by the crowd to demonstrate their intention to emulate the "martyrs of the movement" and fight to the death for National Socialism.

Whereas the Administrative Building served the party administration until the end of war, the representational functions of the Führer Building shifted during the Thirties to the Reich Chancellery in Berlin as well as to Hitler's residence in Obersalzberg. The only major political event for which the Führer Building played an important role as an architectural backdrop was the signing of the Munich Agreement at the end of September 1938, which permitted Germany's annexation of the Sudetenland in Czechoslovakia.

National-Socialist propaganda characterized the party building architecture in Munich ("capital of the movement") as an exemplary ideal. Similarly, Dachau, the concentration camp erected in 1933 north-east of Munich, would become a model for the later development of the National Socialist extermination camp system.

At war's end, the US military initially used these barely damaged large-scale buildings as a "Central Collecting Point" to gather art works that had been looted by the Nazis. Eventually, both buildings were released for use by cultural institutions.

The pillars of the Temples of Honour were demolished in 1947 and, about a decade later (1956/57), their foundations became platforms for plants. The overgrown relics of the Nazi era, together with a Königsplatz that was landscaped in 1988, became, in a literal sense, a memorial of how to deal with a Nazi-imprinted architectural space: let the dust settle and the grass grow.

One sign of change in the mastery of that past is the Munich Documentation Centre for the History of National Socialism, on the former spot of the Brown House on Brienner Straße, which is scheduled for opening in 2015.

Iris Lauterbach

THE NAZI PARTY ADMINISTRATION
STRUCTURE AND BUREAUCRACY

Two large departments of the "Reich Administration of the National Socialist Party," headquartered in Munich, functioned to support Hitler's regime to the end: the offices of the Reich Treasurer and of the Deputy of the Führer. Their work aimed, among other things, to unify party and state and to mediate the power and influence of party and state organizations. Reich Treasurer Franz Xaver Schwarz (1875–1947) – member of the Nazi Party since 1922, participant in the Beer Hall Putsch of 1923, and, starting in 1925, a principal in the party's new organization – resided in the Administrative Building. Holding Hitler's general power of attorney concerning all proprietary affairs of the Nazi Party and overseeing party membership management from 1933, Schwarz exercised significant influence in financial, judicial and administrative affairs. The number of people employed in his powerful agency, including numerous branch offices, tripled over the years so that by 1942, he was at the head of 3,243 employees, which constituted almost 60 percent of the total staff of the "Reich Leadership of the Nazi Party."

The continually redeveloped Nazi district or "forum of the movement" housed the party bureaucracy, which was described by *Völkischer Beobachter* as a "well-ordered and clean administrative machinery" (November 7th, 1936). The Nazi membership card-index, which totalled, at its presumed peak, almost 8 million living members in 1939 was managed from within the Administrative Building. After the war, this index was found to contain more than 10 million membership cards, which included the records of deceased and former members of the party. The Reich's membership card index, as well as the majority of files of the National Socialist Party found after 1945, are now archived in the National Archives (Bundesarchiv) in Berlin.

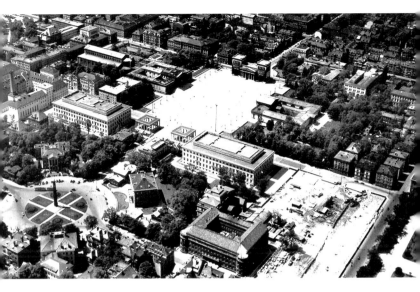

Königsplatz and Maxvorstadt, from the northeast, aerial image, June 1938

The Deputy of the Führer was supposed to fulfil an important political control function within the party as well as act as a link between the Munich party leadership and the Reich's agencies in Berlin. From 1933, until his 1941 flight to England, Rudolf Hess (1894–1987) held the position of Deputy of the Führer. From 1941 until 1945, the department, renamed the "Nazi Party Chancellery" ("Partei-Kanzlei"), was under the leadership of Martin Bormann (1900–1945), whose title was "Secretary to the Führer." The department's staff, consisting in 1938 of 468 members, which increased to 871 by 1944, was, along with other personnel, supposed to be accommodated in the Brown House and the Führer Building. The department also kept offices in Berlin.

Ulrike Grammbitter

THE NSDAP CENTRE

Maxvorstadt and Königsplatz

Königsplatz is the main square of Munich's Maxvorstadt
district. The district was originally laid out during the reign
of Maximilian I Joseph, King of Bavaria. The district occupied
a space outside of Munich's historic centre and city walls. It was
characterized by an orthogonal street pattern whose main east-
west axis was what today is Brienner Straße. During the 18th cen-
tury, this axis, also known as the "Prince's Road" ("Fürstenweg"),
connected the ducal city residence with the summer residence,
Castle Nymphenburg. It formed the main artery from the northern
historic centre to the west

Three squares accentuate this main axis within the Maxvorstadt
district: Karolinenplatz and Stiglmaierplatz, with Königsplatz in be-
tween. Maxvorstadt's design, including its garden-city conception,
originated in the collaboration between the urban planner and gar-
den artist Friedrich Ludwig von Sckell (1750–1823) and the archi-
tect Carl von Fischer (1782–1820). Construction on Karolinenplatz
and Brienner Straße began in 1809. The future King Ludwig I en-
trusted the design of Königsplatz, whose completion took until
1862, to the architect Leo von Klenze (1784–1864).

According to the will of Ludwig I, the Königsplatz was supposed
to be a forum, celebrating the classical art of the ancient world.
Three solitary buildings frame the elongated rectangular area of
the square (image, p. 9). The Glyptothek with its collection of an-
tique sculpture and today's State Collection of Antiquities are
located across from each other in the middle of the northern and
southern sides, respectively. Framed by parks, the propylaea form
the western end of the square. Trees optically screened the eastern
side of the square until 1933.

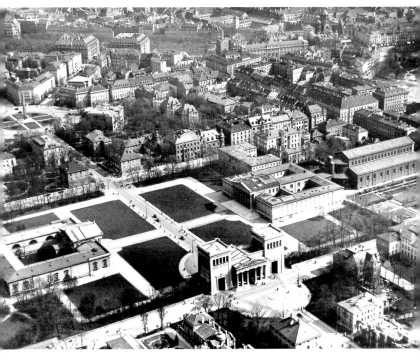

Königsplatz and Maxvorstadt, aerial image taken from the northwest, circa 1932

From the Barlow Palace to the Brown House

After World War I, the Maxvorstadt district with its palaces and surrounding large gardens underwent changes in its social composition. Many of the owners could no longer afford the expense of maintaining the buildings. Some of the houses were broken into multiple rental units, others were occupied by big firms, and still others remained empty. In 1930, the architect Fritz Gablonsky from Bavaria's state planning department warned against the creeping decline of the district. He argued that the character of the Brienner Straße between Königsplatz and Karolinenplatz could only be preserved if the state purchased the vacant

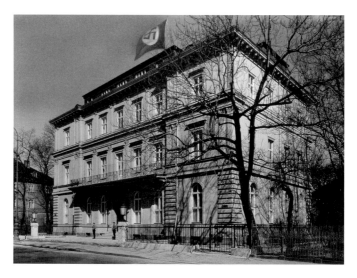

Brown House, Brienner Straße 45, before February 1934

buildings. His advice was not followed. Instead, the National Socialist Party bought the Barlow property (45 Brienner Straße) in the same year for 805,864 Gold Marks. The building was located on the north side of Brienner Straße, approximately equidistant from Königsplatz and Karolinenplatz. The *Illustrierte Beobachter*, a weekly magazine of the Nazi party, celebrated this purchase as a triumph because the party had successfully managed to buy property in an exclusive district like Maxvorstadt, but it concealed the fact that the district had seen better days.

The neo-classical Barlow Palace had been built in 1828 by Johann Baptist Métivier (1781–1853) – since 1824 royal building officer and Klenze's colleague – with the intention of selling it for profit. In Munich at the time, this was not unusual, since King Ludwig I had granted allowances to promote construction on the newly designed avenues. The building was separated by a front yard from Brienner Straße and surrounded by a park and adjoining buildings.

After its completion, Métivier's building was initially leased by Baron Carl von Lotzbeck. In 1838, Fabio Pallavicini, the chargé

d'affaires of the kingdom of Sardinia at the Bavarian court purchased the building. Because Sardinia would later, in 1861, become part of the kingdom of Italy, a misunderstanding developed that the Brown House was the former domicile of the Italian Embassy. In 1866, the Bavarian court photographer Josef Albert purchased the building. In 1876, ownership passed to the English merchant Richard Barlow and, after his death in 1882, the building became the property of his widow Elisabeth Barlow who, in turn, sold it on May 26, 1930 to the National Socialist Worker Association, which acted as purchasing agent instead of the non-incorporated NSDAP.

The "Party Home" as Hitler called it, was meant to become a "cultural document of the Nazi Party." "But what the movement needs is a home, which has to become a traditional site, just like the domicile of the movement is a traditional site." Hitler personally drew up a detailed construction plan, the core areas of which would later form the basis for the spatial organization of the party centre at Königsplatz. Besides organizational and administrative rooms, such as the "Senators' Hall" for 60 people and the Index Card

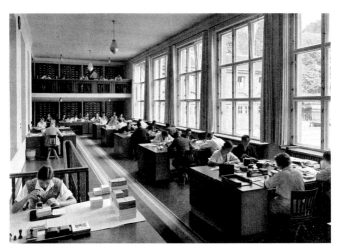

Ein Blick in den Kartothekfaal im Braunen Haus in München

Brown House, card file hall, 1933, source: Deutschland erwacht. Werden, Kampf und Sieg der NSDAP, Hamburg 1933, p. 45

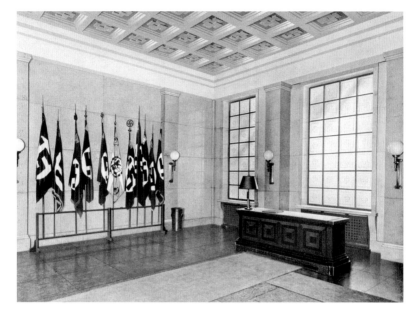

Brown House, Hall of Flags, 1933, source: Die Kunst im Deutschen Reich 8,
"Die Baukunst," January 1944

File Hall for Nazi party memberships, a flag and standard hall was
also envisioned (images, p. 11 and above). Reconfiguration into an
office building began immediately after the purchase of the house.
In fall of 1930, the architect Paul Ludwig Troost (1878–1934) was
called in, who was responsible for the interior reorganization. In
January 1931, the new agency of the NSDAP opened its doors
(image, p. 10). People named the building "Brown House" after the
colours of the party uniform, a term which was adopted by the
NSDAP. Far from being positive, as party officials had hoped, the
press's reaction towards the party's architectural self-representa-
tion was negative as revealed by such headlines as "Munich Palace
of the Nazi-Big Shots," "Palace of Megalomania" or "Hitler Plays
Bavarian King."

Construction History: Party Buildings and the Reconfiguration of Königsplatz

From November 1931, extensions were added on the spacious garden area of the Brown House. On March 27, 1932, Goebbels wrote in his diary, "At Professor Troost's atelier. He designed the new building of our future party house. His design is of true classical clarity. Inspiring it are the ideas of the Führer." Goebbels mentions only one party building. During this time, no mention is made of completing the eastern side of Königsplatz or of re-configuring the square itself or of the Temples of Honour. Between 1932 and 1933, four adjoining lots on Brienner Straße and Arcisstraße were bought by the party and the apartment buildings were demolished.

After January 30, 1933, the building project took on an entirely new political dimension. The NSDAP had become the governing party and Hitler had become chancellor of Germany. Because of these power shifts, the redesign of the whole eastern side of Königsplatz was pushed ahead so that an end to the project was foreseeable. Not only were the green spaces at the eastern end of the square taken under consideration by the planners, but also the development of the east side of Arcisstraße. Irrefutable evidence reveals how at least one homeowner was pressured to sell. The owner in question, Alfred Pringsheim, lived in one of the residential buildings located on a stretch of Arcisstraße, south of Brienner Straße (images, p. 14 and 15). Descended from a wealthy factory owning family, Pringsheim taught mathematics at the University of Munich. He was a member of the Bavarian Academy of Sciences and belonged to the leading circles of Munich society. His collection of Renaissance majolica and silver was among the most distinguished collections in Europe. In 1890, Pringsheim and his family moved into the building on 12 Arcisstraße, which he had commissioned to be built in the German Neo-Renaissance style by Berlin's renowned architectural firm, Kayser & von Großheim. It was one of the first buildings in Munich to be equipped with central heating, electrical light and telephone. The Pringsheim House was an important social and artistic gathering place, which brought together mainly musicians and painters but also writers. Hedwig Pringsheim, Alfred Pringsheim's

wife, was the daughter of the suffragette Hedwig Dohm. The only daughter of the couple, Katia, married Thomas Mann in 1905. Although Pringsheim was Jewish, he called himself nondenominational; his wife's family had converted from Judaism to Protestantism. The children of the Pringsheim family were baptized Protestant.

Thomas Mann noted in a June 24, 1933, diary entry: "Latest news about the destiny of the house on Arcisstraße, whose dispos-

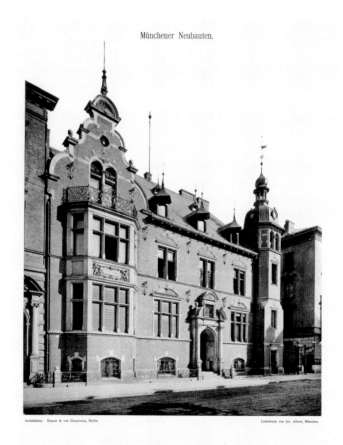

Pringsheim Palace, 12 Arcisstraße, source: Münchener Neubauten, 1896

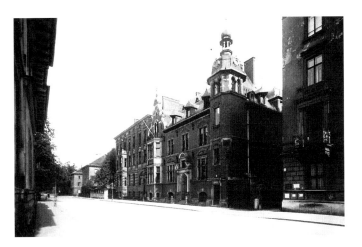

Arcisstraße, from the south in the direction of Brienner Straße, Pringsheim Palace, 12 Arcisstraße, on the right, before 1931

session with or without recompense is imminent. The old people have to leave the house in which they have resided for forty years to make space for another one of the garish party palaces, which shortly are supposed to fill the whole district. The fate of the aged couple is dark and dubious, like the fate of their collection and art works." In August 1933, Pringsheim gave in to the pressure and sold his house and property for far less than it was worth (600,000 Reichsmark) to the National Socialist Party, in this case represented by Reich Treasurer Franz Xaver Schwarz. In November 1933, the Palace and two other adjoining houses were demolished (image above). The corner buildings, conceived during the start-up phase of the Maxvorstadt, at the intersection of Brienner Straße and Arcisstraße, were already demolished. At the southern corner, stood the former house of the architect Carl von Fischer, who built it for himself in 1810. On the northern corner, stood its companion piece, constructed by Joseph Höchl in 1832 for the painter Julius Schnorr von Carolsfeld (images, p. 9 and above). Both buildings marked the junction from Brienner Straße onto the Königsplatz and therefore carried an important urban function. In his article for the magazine, *Das Bayernland*, under the revealing title, "Adolf Hitler, Master

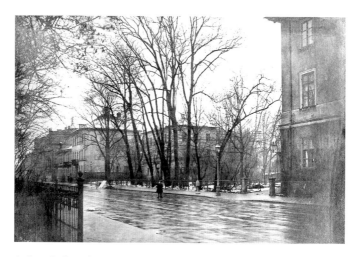

Arcisstraße, from the south, on the right the corner-house 44 Brienner Straße, before February 1934

Builder of the City," National Socialist Hanz Zöberlein, head of Munich's Culture Office at the time, rendered the following judgment about the demolition of these stately buildings erected by well-known architects: "A series of unsightly old buildings, which added nothing of value, were demolished to provide the necessary monumental closure to the eastern end of the square."

Already in April 1933, the NSDAP had submitted to Munich's local construction approval board plans for an administrative building along Arcisstraße. The plans, which merely mentioned a preliminary project, were approved in July of the same year. One can only speculate as to why no final plan was submitted. Either the enlargement towards the north side of Arcisstraße had not yet been fully developed, or the NSDAP, which, at the time of application, in Bavaria had been in power for barely a month, did not want to test how much resistance they would encounter from the urban authorities to their plans for radically changing the East side of Königsplatz. In September 1933, *Völkischer Beobachter*, the daily newspaper of the Nazi Party, reported on the beginnings of the construction of a new Administrative Building at Arcisstraße. The article

emphasized the increased employment that the large-scale project would bring. Accompanying the article was a picture of the construction site, subtitled "Work and Bread." Reading the article, members of the local construction approval board noted the discrepancy between the scale of the reported building plans and the lack of submission of any final construction plans. In a secret meeting, board members deliberated how to proceed against this illegal new building construction but there was a reluctance to confront the new chancellor. The preferred strategy was to demand the submission of final plans and a halt to construction. Although the NSDAP did not submit the required plans until October, construction continued nevertheless without interruption. In the application, the term Führer Building is mentioned for the first time. Not until 1934 did the project pass muster with all of the required authorities and gain final approval. Until then, one of the first representational large-scale buildings of the NSDAP was, in effect, an unauthorized and, therefore technically illegal, construction. For this reason, the construction of this building, so freighted

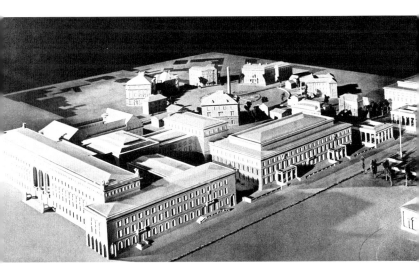

Model of the party buildings at Gabelsbergerstraße and Arcisstraße, in the front, to the left, the unfinished chancellery building across from the Old Pinakothek, "Atelier Troost", 1938, source: Die Kunst im Dritten Reich 3, "Die Baukunst," May 1939

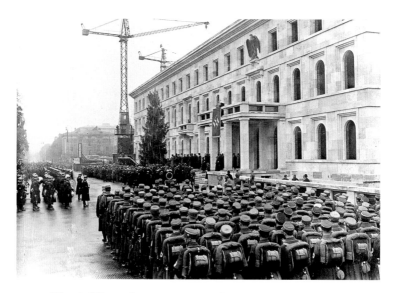

Führer Building, roofing ceremony, November 3, 1935

with importance for the NSDAP, did not include a cornerstone-laying ceremony. By contrast, the party organized a pompous cornerstone-laying ceremony for another of its big projects in Munich, the "House for German Art."

The final new construction project of the NSDAP's centre envisioned two large, horizontally-stretched out, similarly-designed buildings on Arcisstraße (images, p. 17 and 19) The Führer Building, located north of the intersection of Arcisstraße and Brienner Straße, was meant to serve symbolic functions, while its companion piece south of the intersection, the Administrative Building, was supposed to house the files of membership cards and the agencies of the Reich Treasurer. Since the Führer Building and the Administrative Building replaced several pre-existing buildings, the street numbers changed. The Administrative Building, located where the Pringsheim House once stood, now became Arcisstraße, number 10. Arcisstraße, number 12, which had formerly been the address of Pringsheim House, now became the street address of the Führer Building. This change of street addresses has occasionally resulted

in the false impression that the Führer Building was built at the spot where Pringsheim House once stood.

The two temple structures were located where Brienner Straße entered Königsplatz. They evoke the presence of the pre-existing buildings that had been demolished (image, p. 21). The Reich's press office of the National Socialist Party provided a self-serving interpretation of the redevelopment of the square: "Thus, one plan emerged from the many design proposals, a plan that would combine the Brown House and two monumental buildings (Führer House and the administrative building of the NSDAP) with the two temples of honour, "Eternal Watch," into a unified and integrated monumental site design for the square. All this, in accordance with the Führer's wish and will to provide the German people, whose unity he had effected, with a consecrated site and meeting place."

In January 1934 Troost suddenly died. A state funeral was arranged for the "Führer's Master Builder," with the most important leading figures of the Nazi Party participating. The widow, Gerdy Troost (1904 – 2003), Troost's collaborator, continued to lead the

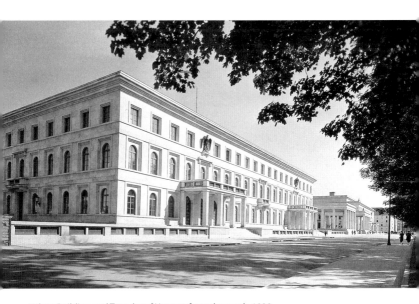

Führer Building and Temples of Honour, from the north, 1938

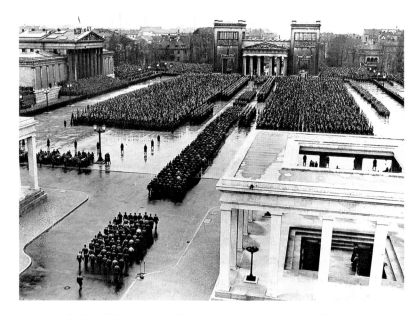

Dedication of the newly remodeled Königsplatz with the transfer of the sarcophagi of the 16 "blood witnesses" to the Temples of Honour, November 9, 1935

construction agency under the name, "Atelier Troost," together with her husband's longtime office manager, Leonhard Gall (1884–1952). After Troost's death, a question arose among the expert public about the extent to which the planning of the new construction had at all advanced. Speculations about the issue were laid to rest by a March 1934 exhibition at the Old Botanical Garden Pavilion, where the models of the two party buildings and the now so-called Temples of Honour, as well as the redesign of the Königsplatz, were showcased. To the south, joining the Administrative Building in the direction of Karlstraße were a district heating plant with chimney building, a post office, as well as various offices. At the exhibition, for the first time, a broad public could see that what had originally been a plan for expanding the Brown House had become a large-scale construction project which not only envisioned a re-configuration of the eastern end of Königsplatz but also a rearrangement of the entire square. The exhibit of the new construction plans and

models in March 1934 were accompanied by a press campaign which can be interpreted as an official statement. Here, the NSDAP evoked the classicism of King Ludwig I and his architect Klenze, linking it with classical antiquity, from which, Hitler, as the "new patron of Munich," was taking his inspiration.

In accordance with the party line, the professional press cheered on the large-scale urban construction project. The choice for the Königsplatz location and the construction of the party centre with accompanying Temples of Honour were represented as the product of a design, which Hitler allegedly had already finalized long before his seizure of power. Troost's part in the project was presented as a mere realization of Hitler's ideas.

Begun in August 1933, construction of the Führer Building was carried out by the firm Hochtief AG München. After construction on the Administrative Building was started in February 1934, the shells of the two buildings were completed in August 1934. Starting in

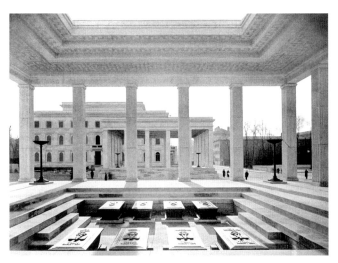

Paul Ludwig Troost Die Ehrentempel und der Verwaltungsbau

Temples of Honour with sarcophagi, from the north, source: Das Bauen im Neuen Reich, 1940, p. 15

21

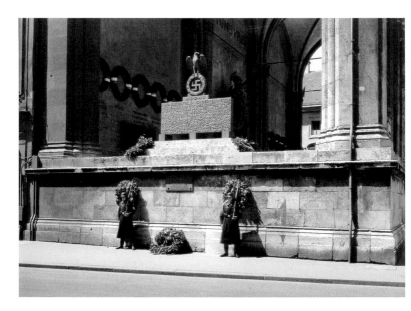

*Residenzstraße, "Feldherrnhalle," Nazi party commemorative plaques
(design: Paul Ludwig Troost) for the "martyrs of the movement" (above) and
for the police officers shot by Hitler loyalists on November 9, 1923 (below), 1933*

January 1935, two underground connecting passages, crossing
under Brienner Straße, were built. In May 1935, construction of the
Temples of Honour was begun. On November 3, 1935, to great pro-
pagandistic acclaim, the roofing ceremony for the party buildings
took place with Hitler and his entourage in attendance (image,
p. 18). Hitler let himself be celebrated by the press as a visionary
city planner who not only followed in the footsteps of Bavaria's
King Ludwig I, but who also was the "First Master Builder of the
Third Reich." This propagandistic title referred to Hitler's purported
dual roles as the statesman who established the Reich on a new
foundation and as the builder who was shaping the architecture
of the Third Reich in accordance with his vision. Six days later, on
November 9, 1935, the inauguration of the Temples of Honour was
celebrated (image, p. 20). At this pseudo-religious event, the so-
called "Martyrs of the Movement" were moved into the temple
structures. On November 9, 1923, Hitler's attempted coup at the

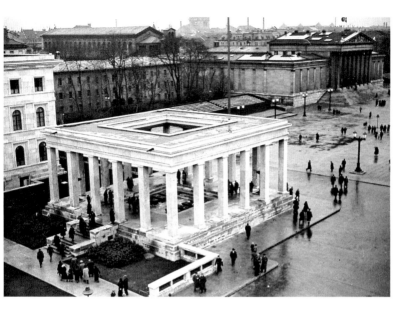

Southern Temple of Honour, after November 1935

Feldherrnhalle (the Beer Hall Putsch) had led to exchanges of gun fire between National Socialist activists and police as a result of which four police officers, fifteen NS-activists, and a waiter working at the nearby Café Tambosi were killed (image, p. 22). In 1935, the mortal remains of the activists were unearthed, the wooden coffins enclosed in tin coffins, and those again enclosed in sarcophagi of iron, the "material of struggle and labour." In a ceremonial procession, the coffins, were escorted through the city bedecked with swastikas to Königsplatz. Under the open sky, the "blood witnesses" were supposed to keep "eternal watch" in the Temples of Honour (images, p. 21 and above). This quasi sacral ceremonial staging was called the "last roll call." The names of the dead were called out and the crowd, as their proxies, answered "Present!" The ceremony was repeated annually with Hitler in attendance through November 9, 1943. *Völkischer Beobachter* reported on November 10, 1935, under the headline, "Resurrection and Eternity," that, "the dead of

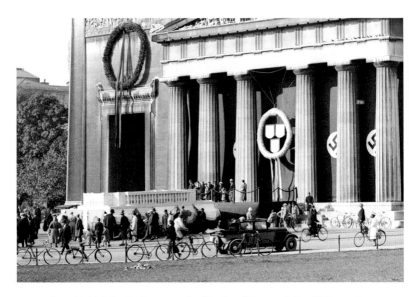

From the historical festive procession "Heyday of German Culture" ("Glanzzeiten deutscher Kultur"), at Königsplatz, in front of the propylaea, model of the "House for German Art" on the occasion of its groundbreaking ceremony, October 15, 1933

November 9th have achieved their status as living sentinels in front of the Houses of the Movement in Munich [...] under God's heaven, in honourable sarcophagi, the revolution's conscience beats on. Munich's celebration of resurrection was among the most powerful and elevated of festivities, [...] sacred hours of heroic devotion, a divine service without church bells or organ music, a divine service with flags and drums, men marching in step, singing, the gratitude of free men of faith [...] We, the old and young National Socialists, thank Adolf Hitler for this unforgettable day and for his sacred re-presentation of German resurrection and German eternity." The cult around the "martyrs of the movement" in the "capital of the movement" represented a high point of the National Socialist festal program in Munich. Only the four "historical processions," which took place in 1933 and 1937 through 1939 in the "Capital of German Art," Munich's title since 1933, came close to achieving comparable programmatic significance (image above).

The Newly Designed Königsplatz: "Acropolis Germaniae"

The sacred ceremonial act of inauguration took place in 1935 on a Königsplatz that Troost's design had completely transformed (image, below). A National Socialist art critic characterized the meeting place as "Acropolis Germaniae," evoking the ancient temple mount of the city of Athens. Enlargement and development of the square remained, apart from the eastern end, unfulfilled. But instead of green spaces and traffic routes, the square was covered with a massive foundation of cement which was then paved with about 20,000 granite slabs each measuring one meter square. The granite slabs were supplied by more than 16 stone quarries in the Black Forest, the Fichtelgebirge and the Odenwald. The massive stone surface was marked only by the gaps between

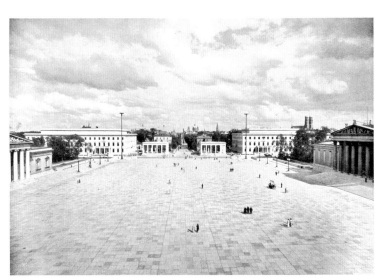

Der Königliche Platz in München: Blick von den Propyläen

Königsplatz, from the propylaea towards the east, 1938, source: Werner Rittich, Architektur und Bauplastik der Gegenwart, 1938, p. 9

the slabs. The classical buildings, losing their monumental aspect, seemed no longer suited to this environment. This change in the architectural landscape was consistent with National Socialist ideas: "In the midst of the extreme vastness," the visitor felt a sense of his "own smallness." The presence of people, "in their diminutive size, lent the massive square of stone an even bigger and more spacious appearance." On the long sides of the square, shoulder-high parapet walls confined the stones, while on the narrower sides, this enclosure feature was phased out. After the completion of the bright panel covering and the surrounding walls, the colour of the façade of the three classical buildings appeared comparatively dingy. Restoration works was started but had not been completely finished for the square's inaugural ceremony.

Standing on the east side, in the direction of Arcisstraße, were two 33 meter high flag poles. Crowned with eagles and swastikas in laurel wreaths, the emblems were based on Hitler's design for the NSDAP standard. The flag poles marked the location of the NSDAP centre. At night, the square was illuminated by 18 two-armed candelabra, which had the same shape as the lamps, designed in 1931 for the Brown House's main gate. From the time that the Temples of Honour were inaugurated, traffic across the square was inhibited, thus depriving Brienner Straße of its function as main western artery.

Königsplatz was included in the design program only as a consequence of the new construction plans relating to the east side, whereupon ideas of its use changed over the course of the construction. From its beginning in the early 19th century, Königsplatz was tied to the notion of commemorating the dead and obsequies for all of the Bavarian kings had taken place on the square. After World War I, many people advocated for a proposal to create a memorial site for the war dead here. A 1924 design that was publicly discussed but not implemented by the architect Otho Orlando Kurz (1881–1933), which Troost and Hitler were certainly familiar with, influenced Nazi planning for the square. It proposed replacing the green spaces with stone panels and erecting a hall on the square's eastside in the direction of Arcisstraße, in which "all of the names of Munich's war dead could have been displayed." In addition, Kurz had envisioned positioning four times four sarcophagi on the long

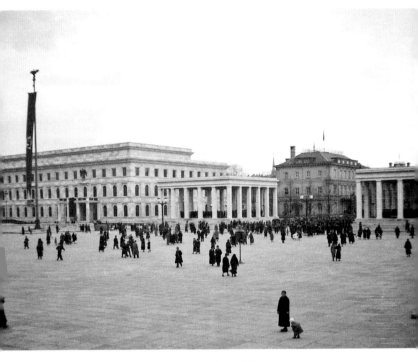

Königsplatz and Führer Building, from the southeast, fall 1937

sides of the square "as symbolic memorial for the martyrs of the fatherland."

In the first plans of the NSDAP, Königsplatz was to be remodelled into a space for party meetings and rallies. This idea allowed Troost to connect to the traditional uses of the square. From its beginning, the square had primarily been a stage for middle class tributes and festivities, including the birthdays of monarchs, noted statesmen, high ranking military figures as well as acclaimed artists. After World War I, the square mainly hosted right-wing party rallies. From the time that the NSDAP established its office in Barlow Palace, the party used the square for its activities as well. During a conversation which was published in *Völkischer Beobachter*, Troost himself

spoke of remodelling his design in relation to the ancient Germanic corral, a well-fortified area, whose purpose was defence against an outside enemy. After Troost's death, this "non-classical" interpretation was never mentioned again. The comment can be seen to be in accordance with the NSDAP's militancy in the time before it took power in 1933.

From 1934 through the following year, the NSDAP's initial conception did not foresee the use of Königsplatz as a commemorative site for the dead – that use would come later with the central function of the Temples of Honour – but as a meeting place, "a framework for the large rallies by the German people who through the Führer's spirit had become a conscious nation." From the start, explicit mention was made of the urban context of the site with the party's centre, but using the temple buildings as mausoleums was not part of the early design. They were initially planned as memorial halls, in which name tablets were supposed to be set up, "of men [...] who rendered outstanding service to the movement and the nation." The "Honour Halls" came to be called "Temples" and finally "Temples of Honour," less frequently, "Eternal Watch." Only in August 1934, a year after construction had begun, was the final composition of the new building of the party's centre decided. The decision to use the "Temples of Honour" as mausoleums, did not, however, result in any changes to the square's design. Of the rising costs of about two million Reichsmark, which were accrued during the building activities for the square, one fourth each was covered by the NSDAP and Bavarian state, the rest of the balance was paid by the city of Munich. During the Nazi era, the name "Royal Square" ("Königlicher Platz"), as an alternative to "Königsplatz," came into use. In fact, the National Socialist mayor of Munich, Karl Fiehler, proposed officially adopting the new name but Hitler opposed the renaming. Nevertheless, in several contemporary publications and official writings, both names appear, oftentimes even side by side.

Architecture

The completed project combined two large, horizontally stretched buildings with two smaller cube-like forms (image, p. 25). The temples mimic the gate functions of the propylaea, located across, and, in their composition, they quote the steeple-endings of both pylons. The three-level party buildings are 85 meters in length, organized by 21 window axes, 45 meters deep and with a height, by contrast, of only 23 meters. The roof is hidden

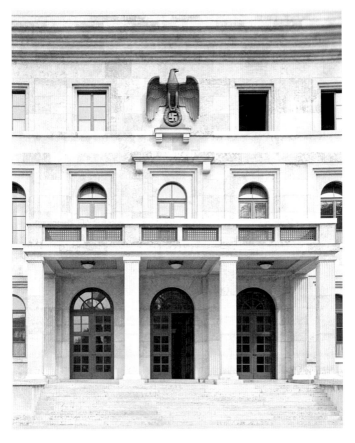

Führer Building and Administrative Building, entrance setting, 1937–45

by a high roof parapet. While the composition borrows from the neo-classical style of Königsplatz, it does not adopt the graceful ornamentation of the buildings. Pillar halls are placed in front of the entrances, which on the main floor include broad balconies. Recalling the motif of the Temples of Honour, these halls offer a way to bring the horizontally stretched party buildings into harmony with the cube-like temples. At the same time, they counterbalance the regression of the large-scale buildings behind the building line. The buildings' only ornamentation were the eagles with the swastika emblem in their claws, which crested the wall above the pillar halls in the first floor. Design features already to be found in Troost's early building structures, now become canonical motifs of the representational architecture of the NSDAP. These features include, the fluted pillars, the spare ornamentation of the façade produced by the alternation of protruding and contracting openings and cornices, the sole ornamental feature is an angular meander, which strongly resembles the shape of a swastika. This ornamental feature is already present in Troost's cruise ship designs, dating from the 1920s. The arrangement of the façade does not give any clues about the building's interior. The main façades are instead staged as showcases, which consider the view of the buildings from Königsplatz. Looking from the propylaea towards the east end of the square, next to the temples, one could only see one half of each of the two main buildings. This explains the bisection of the façade. Each half of the façade has its accentuated middle axis and was therefore able to stand independently. The arrangement of the homogenous façades contradicted an architectural convention which has been valid since the era of historism: "Function should always determine the form and expression of a building." In this case the buildings served different functions: The building located on the northern part of Arcisstraße, the Führer Building had a representational function, while the building on today's Katharina-von-Bora-Straße housed the party administrators. Despite the violation of architectural norms, critics were full of praise: "The buildings' façades have logically followed the design from the floor plan." The façades are wainscoted with lime stone from Kelheim mixed with coquina for the base, tying in to the colour shades of the Königsplatz buildings, on whose walls marble from Unterberg is superimposed.

University of Music and Performing Arts Munich
(former Führer Building), northern inner courtyard, 2009

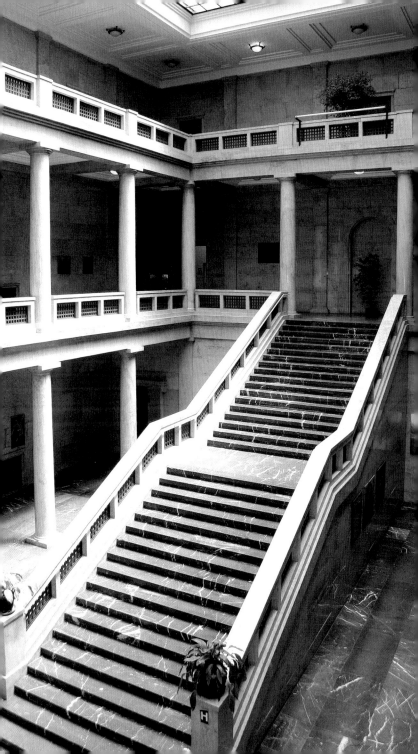

Administrative Building, northern inner courtyard, stairway

The floor plan of both buildings follows a unified, four-winged design. With a transverse section in the middle, it contains two roofed inner courtyards (images, p. 45 and 59). Since the late 19th century, the arrangement of two inner courtyards had been common for large administrative buildings. Unusual in this case, however, is the relocation of the entrance from the centre axis to the middle of each respective building element. This innovation considered the appearance of the façades as well. This approach doubles the number of traffic routes. Each courtyard has its own staircase, which is developed into a hall stairway. From a spatial viewpoint, the duplication of the stairs was completely sensible,

*Central Institute for Art History and other Cultural Institutes
(former Administrative Building), northern inner courtyard, stairway, 2009*

since the Führer Building was supposed to absorb up to 700 people during events, and the Administrative Building accommodated at least 200 permanent staff people.

The hall stairways receive their light through glass roofs which illuminate as well the hallways located in the inner part of the building and lacking any outside windows. Secondary staircases in the side wings are accessible through their own entrances along the side façades. In the middle sections, between the two inner courtyards, one hall each was respectively arranged. The centre point of the Führer Building was supposed to be a congress hall for 700 people. This hall was intended to replace the so-called Senatorial

hall – as the assembly room of the Brown House was called – which held only 60 seats.

The new hall, extending over two floor levels, was illuminated by a glass roof, its rear wall formed into a semicircle (image, p. 45). This focal point of the Führer Building, upon which the whole floor plan was organized, was changed in 1936 into a less formal hall. Its function remained unclear, since the building already possessed a reception and foyer hall (image, p. 49). By 1936, the interior had been partly finished, but the work was removed again, presumably because of plans developed in 1935 for a Reich Congress Hall on the Nazi party rally grounds in Nuremberg, which would have made the assembly room redundant. The hall in Nuremberg was conceived for 50,000 people instead of 700. The Führer's Study, unmentioned in any 1934 and 1935 reports, was moved away from the centre axis, to the south-western part of the building, which was oriented towards Königsplatz (image, p. 53). Dividing the building in two halves, the study room was located in the middle axis of one half. Again, design was driven by showcasing needs rather than work functions. The large balcony above the pillar hall was accessible from the Führer's Study.

Because of the buildings symmetrical arrangement, the same two level hall, illuminated from above, is found in the midsection of the Administrative Building, a structure which was explicitly not conceived to serve representational purposes (image, p. 59). The hall was designated to be library for literature about administrative law (images, p. 35 and 36). There are differences relating to the interior design of the stairways in the twin buildings. The representational hall stairways of the Führer Building are dominated by a single flight of steps and the galleries are supported by columns (image, p. 31). The stairs of the Administrative Building, on the other hand, are removed from the centre. It showcases a double-run stairway, leaning on the middle section. The galleries are supported by pillars instead of columns (images, p. 32 and 63)

The buildings, whose cores were reinforced with Ferro concrete, feature future state of the art construction design, including elevators for people and freight, floor heating, and low pressure steam heating systems. During the summer, the glass roofs could be sprayed with a tubular system to reduce heat absorption from solar

Central Institute for Art History, first floor,
large reading room of the library, 2013

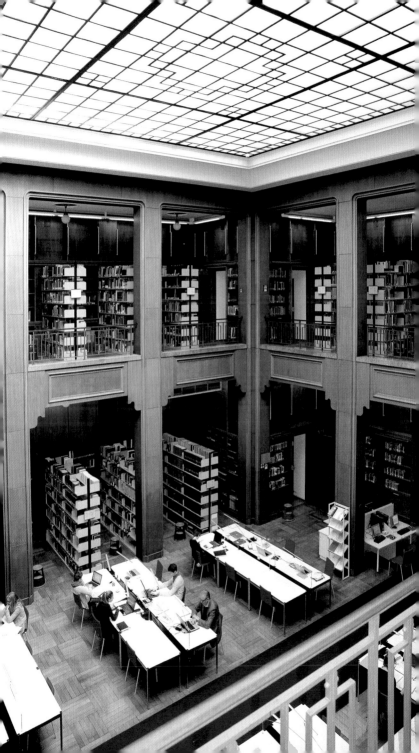

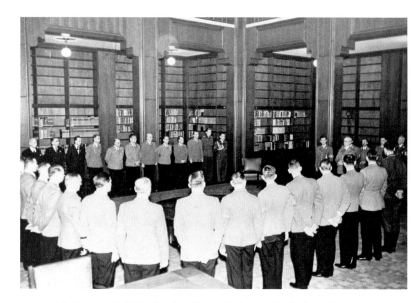

Administrative Building, first floor, library, site for speeches by the Reich Treasurer Franz Xaver Schwarz, February 9, 1942

radiation. A heating system kept the glass roofs free of snow. Mobile scaffolding was incorporated into the roof design, allowing travel across the glass, to repair any damage. Sixty loudspeakers were built into the ceiling of the atrium's galleries in the Administrative Building, permitting broadcasts and announcements to be heard throughout the building. Located in the basement, and on the entire west sides of both buildings, next to the technical facilities, were air raid shelters. They were equipped with airtight security gates and protected by 2.50 meter-thick Ferro concrete ceilings. Both buildings are connected by two parallel tunnels which can be accessed from the basements, the so-called "walking tunnel" ("Gehkanal") and the "pipe tunnel" ("Rohrkanal"). In the latter, all supply circuits, starting with the heating plant (today 6–8 Katharina-von-Bora-Straße) were installed. An air-conditioning system processed the air from the garden which moved through large shafts.

In the representational architecture of the Nazi era, technique does not carry the same aesthetic significance as it does, for example, in modern architecture. This is explicitly highlighted by the National Socialist art historian Hans Kiener: "The fact that the monumental buildings of the Nazi party provide all the facilities of modern hygiene and modern comfort in an exemplary way, allows one to recognize that the achievements of modern technique can easily be reconciled with the most noble and dignified design. [...] Today, some architects are still dominated by technique; only when the architect dominates the technique, as it is the case here, can he unfold architecture's beneficial aspects. In a truly modern building, anticipating the future, all technical achievements must be present, albeit modestly falling into line [...]."

In 1943, the *Guide to Architecture* (*Handbuch der Architektur*), which continues today to be a standard work in the history of architecture, listed the Administrative Building of the NSDAP as a prototype. When Troost's Temples of Honour illustrated the Vitruvius edition of 1938, the first National Socialist construction project gained something like a sense of immortality.

In March 1933, simultaneously with the construction of the party's first representational buildings, the Nazi regime built the first German concentration camp in Dachau. If the party buildings at the Königsplatz showcased the Party's claim to power and its self-image, then Dachau made visible the instruments by which the totalitarian leadership enforced its rule.

Paul Ludwig Troost (1878 – 1934)

Until his death in 1934, Paul Ludwig Troost, the architect of the Nazis' first representational buildings in Germany constructed after their coming to power – the "Party Centre of the NSDAP" and the "House of German Art" – had worked for four years for the Nazi Party. He received his first commission from the party for the remodelling and the interior design of the Brown House in 1930. At that point, he was 51 years old and belonged among Munich's best known architects.

Born in 1878 in Elberfeld, he received his first training in 1894 at the office of the construction firm Haut & Metzendorf, where he was paired up with Peter Birkenholz. In 1896, after two years of practical experience, he and Birkenholz began their architectural studies at the Technical University of Darmstadt. In 1898/99, he became the assistant of Karl Hoffmann. The type of degree he received from the university is unknown. After traveling through Italy for half a year in 1899, he relocated to Munich in 1900. Here he became the office manager for Martin Dülfer, a well-known architect of Munich's "Jugendstil" era. In 1901, the publisher and literary figure Alfred Walter Heymel commissioned his cousin, the artist Rudolf Alexander Schröder, to re-design his apartment at Leopoldstraße in Munich, which housed the editorial department of the journal *Die Insel* at the time. Schröder turned to Troost from Dülfer's architecture firm for help, thus establishing their first collaboration. The interior attracted up much attention from experts and gained widespread approval. Schröder's geometric style elements, which attempted to rationalize the Jugendstil, shaped the young Troost significantly. The art publisher Hugo Bruckmann and his wife Elsa, the latter of whom later went on to become Hitler's benefactor, were welcome guests in Heymel's apartment. A meeting at this time between Troost and Bruckmann seems possible. Troost left Dülfer in 1903 and opened his own atelier in 1904 at 35 Nymphenburger Straße. From then on, he mainly specialized in upper bourgeois villas and interiors. In 1903, he drew up plans for a villa and its interior for the painter Benno Becker in Munich-Bogenhausen. The art publisher Hugo Bruckmann commissioned him for several interior design jobs. The journal, *Dekorative Kunst*, published by Bruckmann dedicated several articles to Troost's oeuvre, thus helping to build a national reputation for him. Troost belonged to the arts-and-crafts movement around the turn of the century, which was supported by Peter Behrens, Richard Riemerschmid, Bruno Paul and Paul Schultze-Naumburg. The architect also came privately to Bruckmann's house at Karolinenplatz, an important meeting place for Munich's cultured society. The art historian Heimrich Wölfflin, the world historian and critic of civilization, Oswald Spengler, as well as Cosima Wagner's son-in-law, the anti-Semitic writer Houston Stewart Chamberlain were among the frequent guests. In the

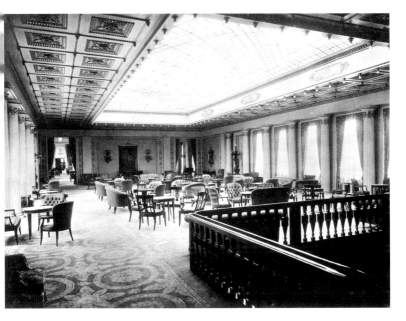

Cruise ship Columbus, North German Lloyd Company, Bremen, hall, interior design Paul Ludwig Troost 1924/25

1920s, Adolf Hitler, Rudolf Heß, and Alfred Rosenberg came and went as they pleased. Starting in 1912, while still living in Munich, Troost took on commissions from the North-German Lloyd in Bremen for decorating luxury cruise ships. His interiors of luxury cruise ships earned him international prizes and a significant international reputation (images above and p. 40). His design style was also characterized as "Cruise Ship Style." Between 1912 and 1932, Troost, who had been appointed professor by King Ludwig III of Bavaria, was mostly active as an interior designer.

In August 1930, Troost became a member of the National Socialist Party and in September he received the commission by Hitler to reconstruct the Brown House. During his life time, Troost was embraced by Nazi propaganda, which portrayed Hitler as the true artist, "the first master builder of the Reich," and gave Troost a supporting role as Hitler's "congenial architect," "the Führer's first

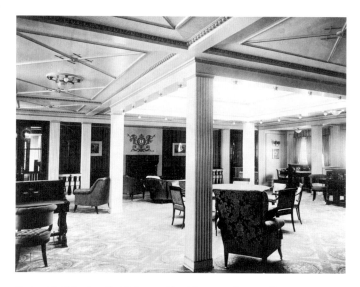

Cruise ship Columbus, North German Lloyd Company, Bremen, library, interior design Paul Troost 1924/25

master builder," who transferred Hitler's ideas to the drawing board. Then, after his early death, Hitler posthumously awarded him with the title, "First Master Builder of the Third Reich."

Troost was also involved in cultural policy affairs, earning Hitler's praise for his "principled rejection of cultural bolshevism." In 1933, he signed an appeal by the "League for German Art" ("Deutscher Künstlerbund"), to fight the "artistic trend setters of the corrosive communist revolution." He was also a member of the 1928/29 founded "Militant League of German Culture" ("Kampfbund Deutscher Kultur") under the leadership of Alfred Rosenberg and, since its founding in 1931/32, a member of the "Militant League of German Architects and Engineers" ("Kampfbund der Deutschen Architekten und Ingenieure"). In 1933, he instigated a campaign against the first president of the "Reich Chamber of Visual Arts," the architect Eugen Hönig, and thereby confirmed his membership in the tight circle around Rosenberg. From April until August 1933, Troost was, in addition, a member of Munich's city council on behalf of the Nazi party.

Leonhard Gall (1884 – 1952)

After Troost's death in January 1934, "Atelier Troost" was founded. It was co-led by Troost's widow Gerdy Troost and his long-standing office manager Leonhard Gall. Apparently, the ambitious widow did not see Gall as a competitor. He remained in the background and to this day today little is known of him.

Gall was born in 1884 in Munich and lived there until his death in 1952. Documentation exists that he was educated at Munich's "Baugewerkschule," allegedly with Peter Birkenholz. This suggests an early connection to Troost, who during his own training also worked with Birkenholz. After a study trip through Italy in spring of 1908, Gall entered Troost's atelier in July 1908, in which he was employed – except for the years of war between 1915 and 1918 – until his death. He became a Nazi Party member in 1932 and was also politically active. Gall had a seat on Munich's city council on behalf of the NSDAP (1936) and was at the same time on the artistic advisory council of the city of Munich. From 1935 until 1941, he was a Senator of the Reich Chamber of Culture; from 1941 until 1945, he acted as vice president. After the completion of the "House of German Art," Hitler awarded him the title of Professor, and in 1944, the "Golden Party Badge." He is further mentioned as the designer of two large projects which were never carried out: the registry building across from the Old Pinakothek on Gabelsberger Straße (image, p. 17) and the "House of German Architecture" on Prinzregentenstraße. Despite having only the credentials of a site engineer, Gall, after Troost's death, called himself an architect – a propaganda "promotion," which was presumably intended to allay any doubts about his competence. After the war, as a "Mitläufer", he was banned from his profession by the denazification court ("Spruchkammer") until December 1948. His attempts to get his career back on track remained unsuccessful.

Iris Lauterbach

CRUISE SHIP STYLE AT KÖNIGSPLATZ
THE INTERIORS

Gerdy Troost (1904 – 2003)

After the death of Paul Ludwig Troost in January 1934, his widow, together with Troost's long-time collaborator, Leonhard Gall, founded the "Atelier Troost," which was responsible not only for the party buildings at Königsplatz, but also for the "House of German Art," the interior design of Hitler's private apartments in Berlin, Munich and Obersalzberg, as well as for other representational official residences. Born in Stuttgart, Gerhardine (Gerdy) Andresen had attended the secondary vocational school for girls from 1910 – 1920 in Düsseldorf and in Bremen, where – after receiving her degree – she joined her father in the "German Holzkunstwerkstätten"(woodcraft workshop). There, she met Paul Ludwig Troost, one of her father's clients. In 1924, she moved to Munich, where the quarter century older architect was living. Neither before nor after the wedding in 1925 did Gerdy Troost, who called herself an "interior decorator," finish an academic education, as, for instance, as an interior designer: an obvious deficiency, which did not harm her career before 1945, but became an issue after the war before the denazification court. She appeared to have used her role as the young wife of a renowned architect to train her aesthetic judgement. After her husband's death, Gerdy Troost, who lacked any educational qualification, took over the leadership of the "Atelier Troost," which was now responsible for the execution and interior design of the large party buildings. Leonhard Gall, likewise only educated as a site engineer, not as an architect, stood by her. Ludwig Weyersmüller is mentioned as the architect of "Atelier Troost." Initially, both Troost and Gall supervised the already started construction projects. On January 1, 1939, Gerdy Troost transferred the atelier to Gall. From then until the end of the war, she dedicated herself to the design of certificates and articles of

daily use – wallets, book covers, gift boxes – for high representatives of the Nazi regime and for state guests. In contrast to Leonhard Gall, Gerdy Troost was wealthy, being the childless sole heir of a successful architect and the director of the construction firm, which erected the representational buildings of the Nazi Party. Member of the NSDAP since 1932 and owner of the "Golden NSDAP-Badge" since 1943, the self-confident widow of the "Master Builder of the Führer" came to be considered an art advisor to Hitler, who awarded her the title of Professor on the occasion of his birthday in April 1937. Only a few weeks later, during the selection of art works for the first "Great German Art Exhibition," a controversy arose between Hitler and Gerdy Troost over the quality of the works of art selected for showing. After 1945, this controversy was accentuated in order to trivialize the politics of the widow who aesthetically, at least, pitted herself against the dictator. The fact remains that Gerdy Troost was until the very end a fervent admirer of Hitler. As apologist for Nazi architecture, she gained prominence with her successful book, *Construction in the New Reich* (*Das Bauen im Neuen Reich*) (1938, new editions 1939 and 1941). From 1938 until 1945, she belonged to the board of directors of Bavarian Cinema ("Bavaria-Filmkunst").

For propagandistic reasons, Leonhard Gall was characterized as an architect – although he was not an architect – and his name is mentioned as designer for furniture pieces of the Führer Building and the Administrative Building. Gerdy Troost may have, as a matter of course, claimed leadership of the "Atelier Troost." She was responsible for the artistic and organizational management of the interior design work; the "Cruise Ship Style" shaped by her husband became the firm's signature design. Not a designer herself, she chose the materials and arranged the furniture. Whether Gerdy Troost, who was classified by the denazification court as a less serious case, belonging to the "Bewährungsgruppe"(probation group), continued her work in the area of interior design after the war is unknown.

Numerous images of the interior of the Führer Building and the Administrative Building were published in *Völkischer Beobachter*, *Die Kunst im Dritten Reich* and other print media. Thus the "Cruise Ship Style" at Königsplatz was presented as the exemplary interior design of the Nazi aesthetic.

The Führer Building

The spatial disposition and the interior design of the Führer Building, opened in September 1937 on the occasion of Mussolini's visit, showcased Hitler's aspiration both to establish representational work spaces and to host large gatherings of the movement. As in the Administrative Building, the first floor is dominated by the hall, which Troost had originally intended as a congress hall but was remodelled into a lounge in 1936/37. As Hitler from the beginning of 1939, spent increasingly more of his time at the New Reich Chancellery in Berlin, built after a design of Albert Speer, and at his Southern German retreat in Obersalzberg, the Führer Building forfeited more and more of its representational functions. With the exception of the Munich Agreement in 1938, most Führer Building events of the following years, including visits by foreign state guests, were of lesser political importance. For protection against air raids, most of the building's furniture was transported to depots outside of the city, which undercut the building's representational use on a large scale. However, the building continued its – less important – function as a site of administrative work until the end of the war. The current arrangement of the rooms is the result of numerous alterations of the last decades. Today, most of the former representational rooms and halls have been fragmented by partition walls into smaller single offices and classrooms of the University of Music and Performing Arts Munich.

Ground Floor

The spacious gallery [1], which sprawled behind the street's façade (image, p. 46) evoked a public presence that was never manifested. At both entrances to the Führer Building access was strictly controlled by the Reich Security Agency and the SS from guard rooms located next to the entrances [2]. From the foyer, a guest would enter the cloak room [3] and pass both inner courtyards [4], which immediately signalled the representational functions of the building, differentiating it clearly from the Administrative Building: monumental flights of steps, used as an architectural tool to stage political choreography, with light marble revetted walls, monolithic

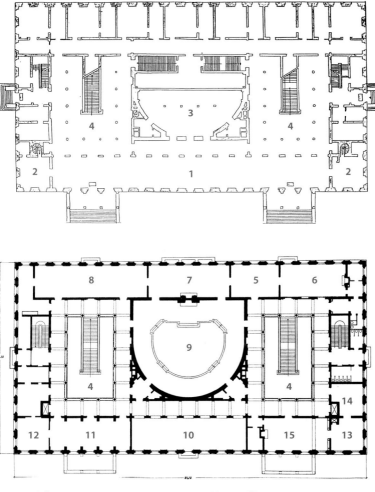

1 Gallery
2 Security guards' rooms
3 Cloak room
4 Inner courtyards
5 Reception room
6 Smoking room
7 Fireplace room
8 Dining hall

9 "Great Hall"
10 Gallery
11 Smoking room
12 Bar
13 Chief adjutant's room
14 Adjutants' room
15 Hitler's study

Führer Building, ground floor (above) and first floor, diagrammed layout

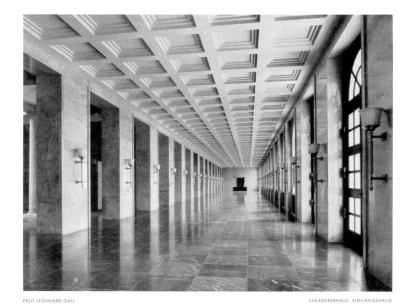

PROF. LEONHARD GALL

DAS FÜHRERHAUS · EINGANGSHALLE

Führer Building, ground floor, gallery, source: Die Kunst im Dritten Reich 2, series 10, 1938

columns and a massive balustrade both made of marble (image, p. 31). Sculptures were supposed to be put in the recesses, at the top of the stairs – Gerdy Troost had figures by Georg Kolbe in mind – but they remained empty.

First Floor

In the eastern and western part of the first floor, a suite of representational rooms showed a sequential arrangement corresponding to the one found in upper middle class apartments (image, p. 45). Apart from a few exceptions, the rooms were mostly decorated with paintings by old masters. In the east wing, the guest initially entered a reception room [5], outfitted with high wall mirrors and a

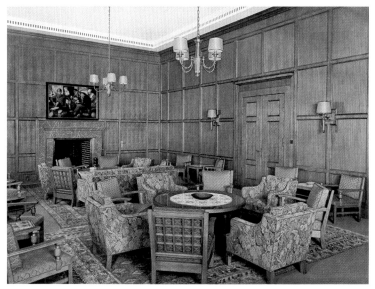

PROF. LEONHARD GALL UND FRAU PROF. GERDY TROOST AUFNAHMEN: FARBWERKSTATT DER »KUNST IM DRITTEN REICH« DAS FÜHRERHAUS IN MÜNCHEN · KAMINZIMMER

Führer Building, first floor, smoking room, source: Die Kunst im Dritten Reich 2, series 10, 1938

grand chandelier. Accessible next door was a smoking room [6] (image above). The Nazi press emphasized that while the Führer himself was a non-smoker, he did not want to deny any amenities to his guests – and his guests wanted to smoke. Evidencing this concession is the existence of even two smoking rooms in the Führer Building, which were densely furnished with many places to sit and relax. The "austere masculine style" of the room is expressed in the dark walnut wall panels, the dark red marble bordering of the fireplace, and the heavily patterned upholstery fabrics. A larger fire-place room [7] with seating accommodations and a many meters long buffet table, followed, adjoining the reception room (image above). A gold plated, panelled ceiling evokes historical castles and residences. Above the doors and setting the tone for cultivated

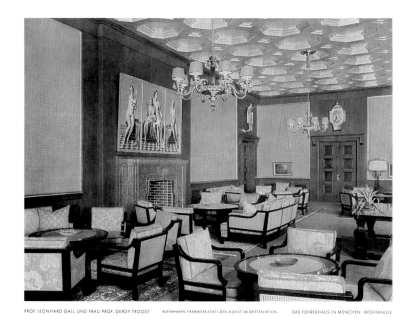

PROF. LEONHARD GALL UND FRAU PROF. GERDY TROOST AUFNAHMEN: FARBWERKSTATT DER »KUNST IM DRITTEN REICH« DAS FÜHRERHAUS IN MÜNCHEN · WOHNHALLE

Führer Building, first floor, fire place room, above the fireplace, the painting,
"The Four Elements," ("Die vier Elemente") (1937) by Adolf Ziegler, source:
Die Kunst im Dritten Reich 2, series 10, 1938

conversation are emblems, also golden plated, representing theatre, painting, and plastic art. The monumental fireplace with marble bordering appeared also in the grand salon. The wall panels were covered with brocade, on which paintings were hung – as in the house of a wealthy art collector: Here again, were mostly works by old masters.

An exception was a painting by the President of the Reich Chamber for the Visual Arts, Adolf Ziegler, found a spot over the fireplace. The often pictured triptych, "The Four Elements," used as an example for official Nazi paintings (today housed in the Bavarian State Painting Collections) was exhibited in 1937 in the "Great German Art Exhibit" in the "House of German Art," where Hitler had

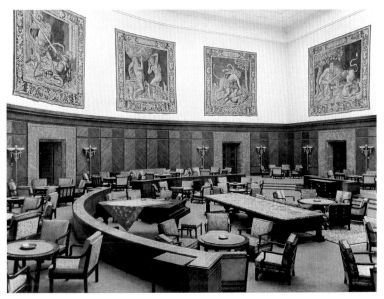

PROF. LEONHARD GALL UND FRAU PROF. GERDY TROOST DAS FÜHRERHAUS IN MÜNCHEN · GROSSE EMPFANGSHALLE

*Führerbau, first floor, Great Hall, source: Die Kunst im Dritten Reich 2,
series 10, 1938*

made arrangements for its purchase: one of the few contemporary
paintings in the Führer Building.

Wall decorations and reliefs were also contemporary works.
The walls of the long dining hall [8] next door, for example, were
adorned with stucco relief, showing party emblems and other
equivalent themes in a design by Hans Panzer, a student of Josef
Wackerle's. In installing the large wall reliefs and calling for a five
meter plus long dining table big enough for 60 guests, "Troost
Atelier" adhered to Paul Ludwig Troost's dining hall designs.

The Great Hall, located in the centre of the building, like the
library in the Administrative Building also illuminated by a glass
ceiling from above [9], was the largest room. It was originally de-

University of Music and Performing Arts Munich (former Führer Building), library (former bar), wall painting, "Spring" (1939), 2009

signed by Troost as a congress hall with ascending rows of seats (image, p. 49). On the occasion of Mussolini's visit in September 1937, the hall was converted into a salon with an elevated gallery. Today, it houses the concert hall of the University of Music and the Performing Arts. The monumental impression was created by the use of rosewood panelling, which stops at the broad marble door frames. The space over the fireplace, featured the plaster relief, "Day and Night" ("Tag und Nacht"), by Leipzig sculptor Emil Hipp. On the walls hung nine large tapestries manufactured in Antwerp

University of Music and Performing Arts (former Führer Building), library (former bar), wall painting, "Summer" (1939), 2009

and displaying the acts of Hercules. They had been commissioned by Duke Albrecht V. in 1565 for the great hall of his Dachau castle. At Gerdy Troost's request they were obtained from the depot of the "Residenzmuseum:" Very much in accordance with the iconography of an early modern prince, the acts of violence of the ancient virtuous hero provided a mythological backdrop for the modern residence of the Nazi ruler. In 1954, they were hung in the new concert hall of the Munich residence, the "Hercules Hall" (Herkulessaal). In 1993, the tapestries were replaced by reproductions.

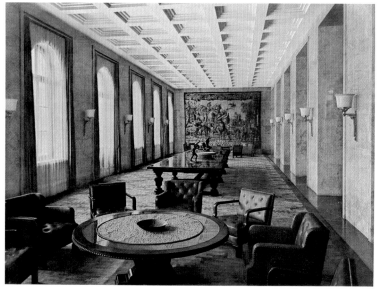

PROF. LEONHARD GALL UND FRAU PROF. GERDY TROOST AUFNAHMEN: FARBWERKSTATT DER «KUNST IM DRITTEN REICH» DAS FÜHRERHAUS IN MÜNCHEN · WANDELHALLE

Führer Building, first floor, gallery, source: Die Kunst im Dritten Reich 2, series 10, 1938

The Great Hall, which had a grand piano and another huge buffet table, was used on only a few occasions according to its functions. Contemporary pictures show that the characteristically low and deep easy chairs, arranged in seating areas, were anything but comfortable. A relaxed and, at the same time, elegant posture could not be assumed by either ladies or gentlemen.

Large public rooms were also located in the building's west wing, facing the street: a gallery decorated with tapestries hanging from its end walls [10] (image above), another smoking room also with dark panelling [11] and a bar [12]. In 1939, the Munich painter Karl-Heinz Dallinger, who also made a name for himself as an interior designer of representational rooms, including air force casinos

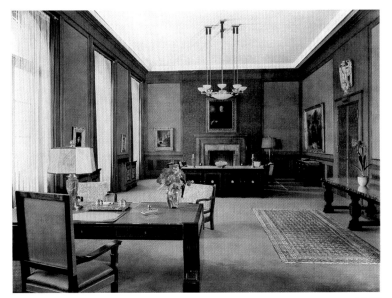

PROF. LEONHARD GALL UND FRAU PROF. GERDY TROOST DAS FÜHRERHAUS IN MÜNCHEN · ARBEITSZIMMER DES FÜHRERS

Führer Building, first floor, Hitler's study, source: Die Kunst im Dritten Reich 2, series 10, 1938

and the "Golden Bar" in the "House of German Art," painted the walls of the bar with illustrations of the four seasons: a garden (spring) (image, p. 50), bathers (summer) (image, p. 51), people harvesting (fall), and a masquerade parade (winter).

Bordering the chief adjutant's room [**13**], which could be accessed through its own elevator, and the adjutants' room [**14**], was Hitler's study [**15**] (image above), located in the middle axis of the southern inner courtyard. It allowed access to a balcony which provided a good overview of Königsplatz. From here, Hitler could show himself on suitable occasions to exultant crowds. With a relatively spare desk, dresser, sideboards and a seating area arranged in front of the fireplace made out of greenish marble, the room

exhibited all the characteristics of a cultivated gentleman's room. As in most rooms of the Führer Building, the floors were covered with carpet and additionally decorated with Persian rugs. Here, paintings also hung from the wall. The numerous photographs of this study and other rooms of the Führer Building supported Hitler's presentation of himself as an art connoisseur and collector. Franz Lenbach's portrait of the Reich Chancellor Bismarck, hung above the fireplace, is as much a part of the conscious political iconography of the room as a globe (in his Hitler parody, "The Great Dictator" (1940), Charlie Chaplin's famous dance with a globe per-haps alludes to the globe in this room).

On September 30, 1938, the agreement for the annexation of portions of Czechoslovakia to Germany was signed in Hitler's work study (image below and p. 55). While Czechoslovakia was not even invited, the visits of the other heads of state – Mussolini, Daladier,

Einigung in München
in der Nacht vom 29. zum 30. September 1938

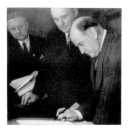

Signing of the Munich agreement in the Führer Building, September 1938, with Adolf Hitler, Benito Mussolini, Édouard Daladier and Neville Chamberlain (clockwise), source: Hitler befreit Sudetenland, Berlin 1938

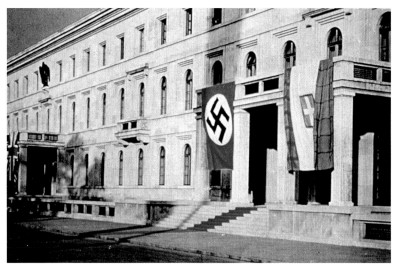

Führer Building with flags on the occasion of the Munich agreement, September 1938

Chamberlain – offered the Nazi press an opportunity to depict the Führer Building as Hitler's "residence." However, the Munich Agreement, which would come to embody the failure of appeasement, was to remain the only political act for which the Führer Building would gain worldwide attention. Finished by the beginning of 1939, the "New Reich Chancellery," designed by Albert Speer in the Reich capital of Berlin, was to play from then on a more important role as a site for Hitler's presentation of himself as a statesman.

Second Floor
The second floor was intended to house the offices of high Nazi Party officials and their staff. However, it is questionable whether these rooms were ever used according to their original functions, because from the end of the 1930s, high party officials were mainly employed in the Reich capital of Berlin. The room at the southwest corner, for example, was meant to serve as Bormann's office [16].

A conference room [17] occupied the middle of the west wing, while the northwest corner housed the Director of the Main Office [18], and an adjoining secretarial room [19]. At the northeast corner, Chief of the Reich Press, Otto Dietrich, had his offices [20]. Next to a hall [21] the picture gallery stretched out over at least nine window axes [22]. Here, Hitler probably had his art experts and dealers show him new arrivals of paintings, looted as part of the Nazism's Europe-wide system of art theft. In that system, the Führer Building played an important role as a way station. Many paintings, intended for Linz's future museum and other places, were stored temporarily in the Führer Building. At the end of April 1945, American "Monuments Men", found a large quantity of paintings in the air raid shelters of the Führer Building.

Sublevel and Basement

The casino, located on the sublevel (now used as the cafeteria of the University of Music and Performing Arts), opened in September 1937 on the occasion of Mussolini's visit. It was designed in the style of a Bavarian brewpub. During receptions, food was sent up from the kitchen in the northeast corner of the sublevel via elevators to the serving rooms next to the dining hall on the second floor. In the basement below, also connected via elevators, food was stored in specifically equipped refrigerated rooms.

Technical Devices and Management

The fixtures and fittings of the party buildings at Königsplatz were state-of-the art. This applied to the heating plant in the adjoining building (6 – 8 Arcisstraße), which heated the Nazi Party buildings in the district, as well as the fire alarm systems, the air conditioning systems, and the communication systems inside the buildings (letter chute). Also state-of-the-art was the sound systems, which allowed broadcast over loudspeakers inside the buildings as well as outside on Königsplatz.

All the furniture of the Führer Buildings and the Administrative Building were newly designed. Most of them were from the "Atelier Troost," which for the most part employed firms from Munich: car-

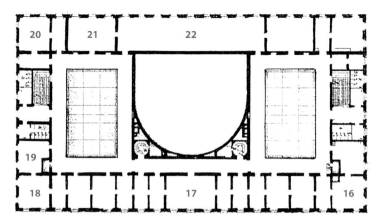

16 Bormann's study
17 Conference room
18 Main Office Director's room
19 Secretarial pool

20 Reich Chief Press Officer's room
21 Hall
22 Picture gallery

Führer Building, second floor

penter and locksmith shops, upholstery services and saddleries.
Textiles were also woven specifically according to Gerdy Troost's
ideas. The workshops of Anton Pössenbacher, in particular, crafted
most of the representational furniture. In their details, the designs
(as, for example, the door handles) resemble the Bauhaus style,
defamed by the Nazi regime. Rather than manifesting a functional
design, "Atelier Troost's" conservative furniture, fixtures and fittings,
conform to a principle of hierarchy. Technical installations and de-
tails are not integrated into the design but instead are concealed.

The Administrative Building

In February 1937, Hitler transferred the Administrative Building over to the building landlord, the Reich Treasurer Franz Xaver Schwarz. In contrast with the Führer Building, which over the years was to forfeit many of its representational functions, the Administrative Building until the Allied occupation actually lived up to the functions for which it had originally been built. Next to the Brown House (the "Party's cradle"), the Temples of Honour and the Führer Building, the Administrative Building also formed part of official visitors' special tours. The index card file halls and registries were supposed to showcase to any visitor the "clean administration" of the Nazi state. The Administrative Building and its architectural design provided Nazi propagandists with opportunities to showcase "the principles of the most scrupulous management" (1937).

The party bureaus of the NSDAP, which already in 1935 had listed their space and furniture needs, were in operation in the building from the beginning of 1937. The Reich Treasurer and his staff were situated in the larger rooms of the first floor, in the westward side of the building, facing Königsplatz. The corner rooms of the first and second floors were reserved for department heads. As many as four administrators worked in each office. These offices, located on the first and second floors, measuring 26 square meters each, were aligned. As many as 80 employees worked in the open plan offices on the ground floor and on the sublevel. On the occasion of the first Christmas celebration, Advent 1937, a large number of employees working in the party buildings had gathered in the festively decorated inner courtyard of the Administrative Building to listen to the Reich Treasurer's speech (image, p. 64).

"Atelier Troost" had designed the representational rooms and their furniture, H. M. Friedmann, the simple office furniture. All furniture was made according to new designs. Hierarchically ordered, the furniture design ranged from tables with protruding curved sides and bar compartments, the straight and plainly designed but monumental desk of the Reich Treasurer to the small narrow tables for the secretaries' typewriters. Massive furniture with a neo-renaissance façade fit in the general ambience as well as modern

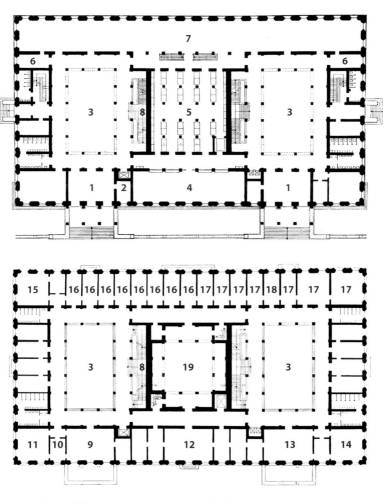

1 Entrance halls
2 Security guards' room
3 Inner courtyards
4 Reception room
5 Index card hall
6 Supervisor of the Reich Registry
7 Reich Registry
8 Stairways
9 The Reich Treasurer's study
10 Adjutant's room
11 Conference room
12 Head of the Administration Department
13 Staff Director
14 Spokesman of the Staff Director
15 Head of the Budget Department
16 Budget Department
17 Accountants' Department
18 Central Pay Department
19 Library hall

Administrative Building, ground floor (above) and first floor, layout

roll-fronted cabinets made out of wood and metal. In 1987, the Bavarian State Department of Monuments and Sites made an inventory of the remaining furniture of the Administrative Building.

Ground Floor

Like the Führer Building the Administrative Building had two entrance halls [**1**]; the more well-travelled entrance was the northern one, where employees and visitors underwent security checks (image, p. 59). This happened by the guards' room [**2**] where members of the Reich Security Service, a division of the SS, checked IDs and issued relevant permits. The glossy polished Jura marble panelling of the walls and pillars, which dominates the entrance halls and the interior court yards [**3**], originates from Kehlheim, while the conspicuously veined, crimson floor cover, came from the Saale Valley.

The corridors around the inner courtyards as well as most of the stairs were covered with linoleum runners. Here – as well as in many other rooms – the hanging lamps remain part of the original inventory. The round openings in the ceiling served as loudspeaker broadcasts. Over the passage to the northern gate, a clock was inserted into the wall, which was typical for an administrative building or factories. Today's eastern wall of the inner courtyard, which can be seen when entering the inner courtyard on the first floor (image, p. 63), has been painted in different shades of black, in a design by Jon Groom (1997).

Almost 40 employees working in the open-plan office of the reception room [**4**] were responsible for putting together the membership books for new members of the National Socialist Party. Since applications were submitted by mail, there was not much public foot-traffic in the building. Registers of real estates and admission certificates were stored in the room between the two inner courtyards [**5**]. The Reich Registry of the NSDAP, whose supervisors had their offices next door [**6**], was housed on the ground floor in a long open-plan office [**7**], which stretched out on the east side of the ground floor across the whole building (image, p. 61). Large tables, with linoleum tops, stood next to fire-proof cabinets of steel, with wooden drawers for the index cards.

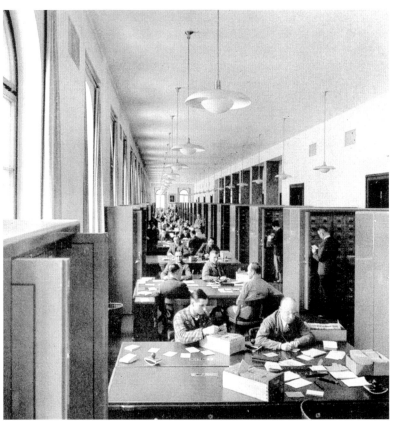

Administrative Building, ground floor, index card registry hall, source: Moderne Bauformen 37, 1938

In order to prevent these index cards and other files from falling into the hands of the approaching Allied troops, officials had one full truck-load after another of millions of index cards and documents removed from Königsplatz buildings to a paper mill in Freimann starting in April 15, 1945. Instead of following the order to destroy the files, the courageous mill owner was able to hide the sensitive material unnoticed by the National Socialists until after the end of the war. In October 1945, the US military government

took over the files and a few month later transferred them to the so-called Berlin Document Centre, where they became the basis of the post war denazification process. Today, the NSDAP card indexes are stored in the federal archives in Berlin.

Sublevel

On the sublevel, another large open-plan office, with the same interior design as the Reich Registry located directly above, managed the index cards of the NSDAP chapter groups. In the middle of the building, directly next door, was the filing depart- ment equipped with three meter high roller shutter cabinets. At the end of the descending stairs from the ground floor, under the inner courtyards, two wide rooms supported by pillars, contained 272 employee lockers.

First Floor

The first floor (image, p. 59) was reserved for the higher agencies. Here were situated the offices of the Reich Treasurer with his adju- tants, staff directors and the heads of division in the west wing. Walking across the northern inner courtyard and up the stairs [**8**], one was greeted by a large scale portrait of Hitler which hung between two scones, staged in a neo-imperial manner (images, p. 32 and 33). While contemporary photos show the index card hall on the ground floor with many employees, busily at their work, the representational rooms of the office holders on the first and second floor seem comparatively lifeless. The aesthetics of a well-groomed gentleman's apartment comes to mind: with a work desk, book ca- binet, sideboard, and seating area. The office rooms bring together all the elements of a "gentleman's study" which, at the beginning of the 20th century, was part of the décor of any upper middle class apartment. This is primarily true for the study of the Reich Treasurer [**9**]. Crimson to dark brown colours dominate the carpets, the Persian rugs, the marble table tops, and the Morocco leather up- holstered chair. From the armchairs of the seating area, one had again a view of a Hitler portrait, which decorated the room with other paintings.

Central Institute for Art History and other Cultural Institutes
(former Administrative Building), northern inner courtyard,
taken from the west, 2009

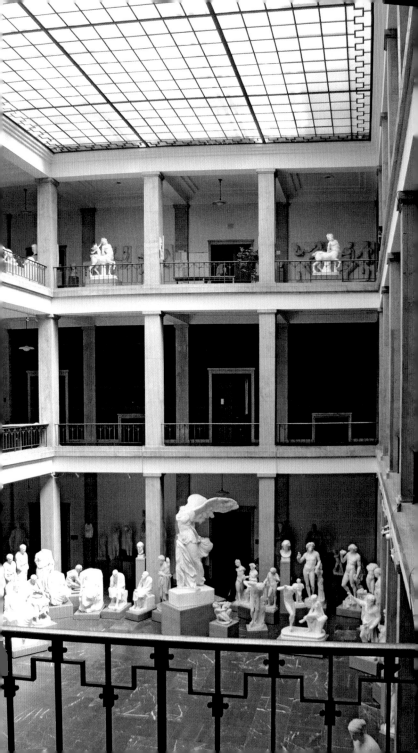

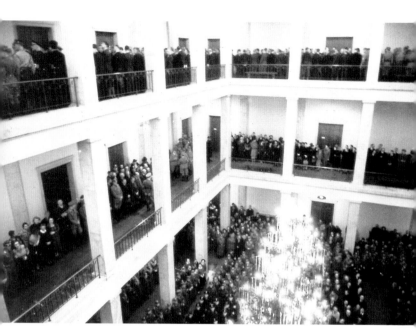

Administrative Building, northern inner courtyard, Christmas party 1937

Included in Reich Treasurer's working area was the adjutants' room [**10**] and a conference room [**11**]. The head of the Administrative Department occupied a large room in the middle of the building [**12**], the head of the staff was in a room with access to the southern balcony [**13**], his spokesman in the corner room [**14**]. From the corner room of the northeast corner of the building [**15**], the head of the Budget Department had direct access to a suite of offices belonging to the Budget Department [**16**], to the Accountants' Department [**17**] and the Central Pay Department [**18**].

The library hall [**19**] extending over two levels is located in the centre of the first floor. Today, it is used as one of the reading rooms of the Central Institute for Art History. Like the interior courtyards, it is illuminated by a glass roof from above (image, p. 35). Spacious floor to ceiling bookshelves, were equipped with special ladders, which could be hooked in to reach the highest shelves. They were

supposed to hold legal literature and books concerning administrative law. As contemporary photos show, meetings and speeches by Reich Treasurer held at this venue occurred in front of mostly empty shelves (image, p. 36). The spatial impression of the hall was dominated by the pillars' and walls' dark oak wood panelling. On a carpet with a stylized swastika pattern stood an enormous round book table with a red marble inlay. It is now found in the entrance foyer of the building. Also to be found in the room was a large globe, a corresponding twin to the globe in Hitler's study in the Führer Building. Both globes were preserved and are now found in the index card department of the Bavarian State Library and in Munich's City Museum, respectively. An installation of blue light boxes (1997) by the artist Andreas Horlitz stand in stark contrast to the dark wood colours of the library hall.

Second Floor

Administrators and secretaries of the Legal Department ("Rechtsamt") and the Membership Department ("Mitgliedschaftsamt") were seated in small offices in the western and northern part of the second floor. The Reich's Financial Accounting Department ("Reichsrechnungsamt") and the Legal Department occupied the southern part, the Department of Human Resources mostly the eastern part. The larger corner offices were here also reserved for department managers. In most of the rooms, as on the first floor, the built-in cabinets of oak wood have been preserved. A large hall in the middle of the east wing was originally planned as a projection theatre with projection capabilities. However, because of fire safety considerations, it could not from the start be used as such.

Iris Lauterbach

EXORCISING DEMONS
THE NSDAP CENTRE AFTER 1945

A s units of the 7th US Army approached Munich's city centre
on April 30, 1945, they found the Führer Building and the
Administrative Building at Königsplatz comparatively intact
(images, p. 69 and 71). The Temples of Honour had survived the
bombardments without damage. The Glyptothek and the National
Gallery (today the State Collection of Antiquities) located across
were heavily damaged, despite the camouflage installed on the
square (image below), which had been in place since the beginning
of 1943. The Brown House (image, p. 67) and the former Degenfeld
Palace located across from the Brown House were destroyed.

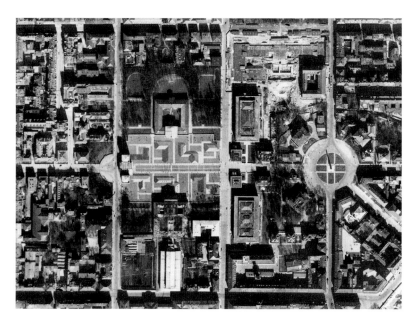

Königsplatz with camouflage against air raids, March 1943

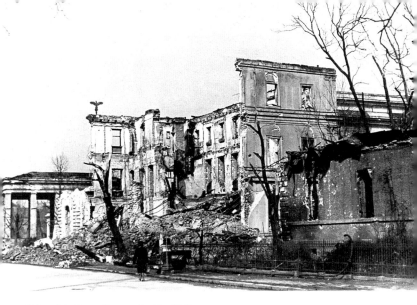

Ruins of the Brown House, after May 1945

The inside of the party buildings, however, presented the American soldiers with an image of devastation (image, p. 68). Looters had turned everything upside down, whether dishes, food or alcohol, and had taken everything useful. Since the American soldiers initially were not aware of the network of underground pipe tunnels that connected the buildings in the area of Arcisstraße and Brienner Straße, the above ground security measures – barbwire, security patrols – they set up immediately did not prevent further pillaging by people familiar with the underground layout. Thus, numerous art works, which had not yet been moved to the outside depots, were stolen from the air raid shelters of the Führer Building. Among these works were valuable paintings belonging to the art collection of Adolphe Schloss, which had been confiscated in France. The prestigious furniture of the Führer Building and many of its paintings, part its interior design, had already been moved during the war years to various locations. The interior of the Administrative Building was mostly preserved. Despite the desolate condition of single rooms, the building facilities of both party buildings were operating as before.

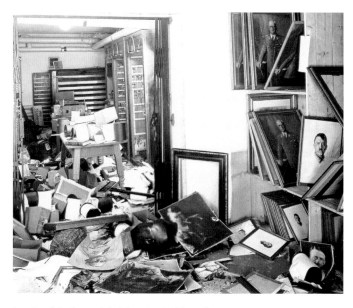

Interior of the former Administrative Building, after May 1945

From the very outset, the American Army in the Bavarian capital, whose centre was heavily destroyed, used the confiscated NSDAP buildings for its own purposes (image, front inside book cover). Taking this necessary step apparently did not pose any ideological difficulties for the American military authorities. The decision to use the former Führer Building and the Administrative Building for cultural purposes, whose legacy continues today, was made at the turn of May/June in 1945. Inventories of Munich museums as well as thousands of art works which had been con-fiscated or illegally acquired by the Nazis inside or outside of the country were stored under partially problematic circumstances in places of refuge in the southern part of the American occupation zone – particularly in Upper Bavaria and the Salzkammergut. In order to secure these art works and to restore the Nazi-looted art to their rightful owners, adequate spaces had to be found in Munich. Since both Pinaotheks and most other museums of the city were

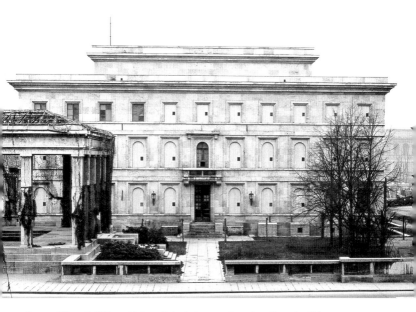

Former Führer Building with boarded windows and northern Temple of Honour with camouflage netting, taken from the south, 1945/46

either destroyed or badly damaged, the two Nazi buildings on the Königsplatz were chosen. The military authorities used the Administrative Building under the designation "Gallery I" and the Führer Building under the designation "Gallery II" as the Central Art Collecting Point (CCP).

In June 1945, the military authorities employed Dieter Sattler (1906–1968) as the leading architect to be in charge of the restoration of the former NSDAP buildings. Sattler, who was the state secretary of the Bavarian ministry of culture from 1947 until 1951 and to whom eventually the responsibility of the buildings was transferred, also played an important role for the post war history of the buildings. Before the beginning of winter 1945/46, damaged spots on the buildings needed to be repaired. The heating plant (6–8 Arcisstraße, today Katharina-von-Bora-Straße) was brought online again. During the process of "architectural" denazification the four eagles with the swastikas were dismounted. Their mounting

holes are still partly visible today. The reliefs with propagandistic content in the dining hall of the Führer Building were also removed.

In the first register of historical monuments published in 1978 by the Bavarian state authorities responsible for monument preservation, the former Führer Building, as well as the Administrative Building, are already listed. In both buildings, structural changes were made to accommodate the NS-interior to the needs of the institutions which had taken up residence. Former grand salons and halls were separated into rooms with only one window axis, stairs and paternosters were closed, book stacks installed. The Great Hall in the Führer Building was used for events and film presentations of the Amerika Haus. In the 1960s, it was remodelled into the concert hall of the music conservatory.

After the war, other former buildings of the Nazi Party, located in the district encompassing Arcisstraße, Karlstraße, Barer Straße, and Gabelsbergerstraße, many of which had survived the bombardment less successfully than the Troost buildings, were taken over by the American military authorities. In April 1947, the Allied Control Council issued its Directive No. 50, transferring former Nazi assets confiscated by the Allies to the German authorities. The Bavarian Ministry of Culture, until 1949 still in collaboration with military occupation authorities, took over responsibility for both party buildings at Königsplatz. After the war, the former post office building (Arcisstraße, today 6-8 Katarina-von-Bora-Straße) was occupied by museum administrators. Today, it houses departments of the Bavarian state tax office.

The southern part of Arcisstraße, starting with the park café at the Old Botanical Garden, to the intersection with Brienner Straße, was renamed in 1957 in honour of the Bavarian Protestant bishop Hans Meiser (1881–1956), who had his official residence at 11 Arcisstraße. Long acclaimed as an upright Nazi opponent, Meiser had, by the end of the 1990s, become a focus of criticism for his anti-Semitic statements. In July 2007, Munich's city council by majority vote decided to change the name of this part of the street, and, according to a resolution of February 2008, to rename the street "Katharina-von-Bora-Straße" in accordance with a proposal by the Protestant church of Bavaria. A lawsuit brought by the bishop's grandson to prevent the renaming of the street was rejected in 2008.

Central Collecting Point (former Administrative Building) with US guard, spring/summer 1945

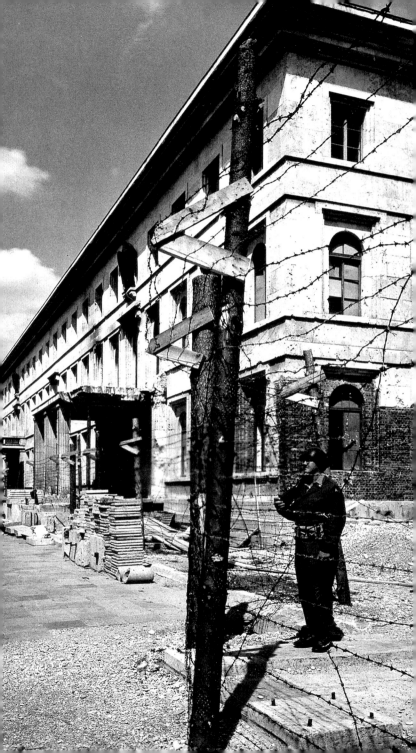

Gallery I

I n the months after the end of the war, the Collecting Point claimed use of Gallery II, the former Führer Building, as well as Gallery I, the former Administrative Building. The constant influx of more Munich art inventory being returned to the city from external collection depots worsened the problem of inadequate storage. In addition, since 1946, more and more museums, which had lost buildings to war time destruction, crowded Gallery I with their surviving collections and department staffs. It was not until years later that most of these institutions could move back into their restored pre-war accommodations or to newly constructed buildings. For example, in 1957, the Bavarian State Painting Collections as well as the Doerner Institute transferred their administration and depots from Gallery I to the reopened Old Pinaothek respectively, in 1981, to the New Pinaothek). Today, the building on 10 Katharina-von-Bora-Straße is used by the Central Institute for Art History, the State Graphic Collection, institutes of the Ludwig Maximilian University together with the Museum for Casts of Classical Sculptures and Reliefs, as well as the administration of the Glyptothek and the State Collection of Antiquities.

Gallery II

S ince the end of the war the Führer Building has also been employed by various and changing institutions. In 1945, the building was still used as an additional depot for art works arriving at the Collecting Point, but soon after, it came to operate exclusively as a storage site for externally held stored and now rediscovered book and archival inventories. Among others, it housed departments of the Bavarian State Library, which, in February 1948, opened a general reading hall. In 1952, however, those departments were able to move back to the restored building by Friedrich von Gärtner at Ludwigstraße. The Bavarian Main State Archive had lost its residence in Ludwigstraße due to war destruction. After the end of the war, inventory that had been stored in emergency

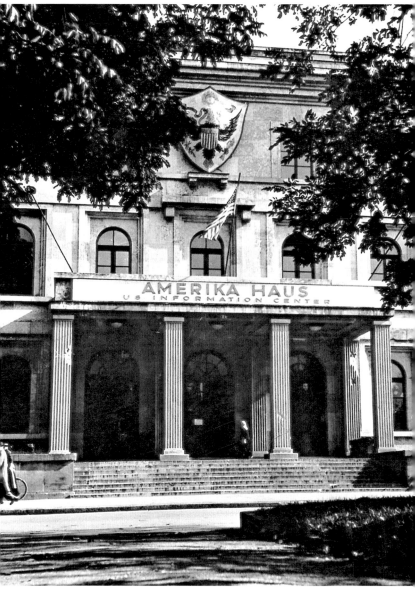

Amerika Haus (former Führer Building), after 1948

depots in surrounding areas was transferred to Gallery II and there found a place in the inner courtyards and spacious galleries. When a fire at the Trausnitz castle in Landshut damaged the archival inventory there in 1961, countless materials and boxes were temporarily secured in 12 Arcisstraße. In 1977/78, the Bavarian Main State Archive moved into the newly constructed building in Schönfeldstraße.

In 1948, the military authorities set up the newly founded "US Information Center" or Amerika Haus in the southern half of the former Führer Building (image, p. 73). After the removal of the Nazi emblem, they marked the now empty spot over the southern entrance of Arcisstraße with their own national emblem. The institution of Amerika Haus was intended by the American military authorities for democratic "re-education" of the German people through promotion of an international ethos of cultural exchange. The Amerika Haus included several libraries and offered a multifaceted program of events with language courses, concerts and movie showings. It became a model for the omnipresent cultural centres of today. The 1957 publication of the novel *Tauben im Gras* (English title: *Pigeons on the Grass*) by Wolfgang Koeppen conveys an atmospheric impression of Munich's Amerika Haus, which moved in 1957 into a newly constructed building at Karolinenplatz, the original site of the then destroyed Lotzbeck Palace. Today, the former Führer Building is used by the University of Music and Performing Arts Munich. The school's predecessor, the Academy of Music (Akademie für Tonkunst) had until well into the war years resided in the Odeon at the Hofgarten, which was destroyed in 1944. In the following years the search for a new permanent residence went on until the summer of 1957, when the University of Music and Performing Arts was able to move into the building on Königsplatz.

The Central Art Collecting Point, 1945–1949:
Art Protection, Restitution and Scholarship

Munich's Central Art Collecting Point (CCP) in the former Nazi building at Königsplatz became the largest art collecting point of the American occupied zone. The beginning of the process of restitution of Nazi-looted art in late spring of 1945 came about through the efforts and collaboration of numerous Allied organizations and departments both military and civilian. The responsible agency of the military authorities in the American occupied zone was the "Monuments, Fine Arts & Archives Section" (MFA & A). Preparations had started years before. The increasing destructiveness of the war and the threat this posed to artistic, historical and cultural monuments, works and collections, triggered concerns both in Germany and among the Allies about the protection of art. From the start, the restitution of looted art

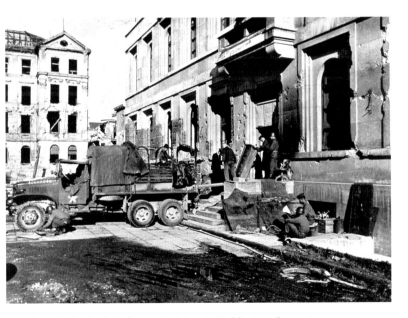

Central Collecting Point (former Administrative Building), southern entrance, committal of art works, 1945/46

was considered a measure that would be need to be taken after the end of the war. The dimensions of the Nazis' success at looting art, which was revealed after more and more collection depots were found starting in April 1945, exceeded all expectations. Eye witness accounts of those officers working for the art protection program who took part of the rescue operations testify to the immense energy expended to deal with the enormous logistical challenges but also to the bewilderment at the quantity of art works whose storage conditions were generally poor.

Many of the artworks confiscated from occupied countries or mysteriously acquired by other means were supposed to be sent to a colossal museum in Linz envisioned by Hitler. Some of the paintings designated for this museum were temporarily stored in the Führer Building. The art gallery on the second floor presumably served as a place for examining and classifying artworks that were looted or acquired through purchase. In order to eliminate any dangers from bombardment, many of the paintings stored at the Führer Building, as well as paintings belonging to the building's interior design were brought to different places starting in 1943. Neuschwanstein Castle, the Buxheim Cloister, and the Herrenchiemsee Cloister, housed the majority of works confiscated in France by the Reichsleiter Rosenberg Taskforce (Einsatzstab Reichsleiter Rosenberg, ERR), as well as the lists of objects and indexes managed by the ERR. After recovery by the American military agencies, these artworks and documents could be analysed. Large numbers of paintings and sculptures were found in the salt mines at Altaussee and Bad Ischl by Salzburg – not even mentioning the pictures and sculptures found in further collection depots in Upper Bavarian cloisters and castles, where the inventory of the Munich museums were mainly stored. In June 1945, transportation of the art works from these temporary storage sites to Munich began (images, p. 75 and 77). The first director of the Collecting Point, the art historian Craig Hugh Smyth (1915–2006), a Navy officer, arrived in Munich on June 4, 1945. He competently overcame the many challenges that faced him. Starting in the middle of June, one truck-load after another brought thousands of crates containing paintings and sculptures, furniture and craftwork to the Collecting Point. There were coins and metal objects, regalia like Saint Stephen's

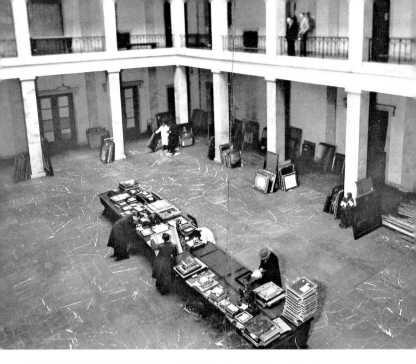

Central Collecting Point in the former Administrative Building, southern inner courtyard, 1945/46

crown from Budapest, furniture and musical instruments, paintings – from the altar in Ghent as well as outstanding works of the Dix-huitième from Paris, the Impressionists and Russian icons – sculptures like Michelangelo's Madonna from Bruges and a cast of Rodin's "Citizens of Calais." The arriving art works were assigned with an entrance number (the so called M or Munich number). Property cards listed information about the work's provenance, storing location, object and technique. Starting in fall of 1945, the Collecting Point began returning works with German provenance. Claims for foreign art works from representatives of the respective countries were considered; claims from individuals were not. At the Munich Collecting Point, these foreign representatives were given the support of German colleagues. The works awaiting processing were arranged in specifically designated rooms according to nationality. Parts of the library collection intended for Linz as well as specialized art history literature from other Munich institutions

were transferred to the CCP and rendered important service in the efforts to identify art works.

Starting in August 1945, the CCP processed return shipments for affected countries. The first particularly prominent art work to be processed, the altar of Ghent, was sent home to Belgium on August 21, 1945. In the meantime, cartloads of art arrived one after the other and continuously at the CCP, since many collection sites of looted art, of library and archival inventories were discovered only gradually. In addition to inventory organized for restitution – which had been intended for the museum in Linz – the collections of Göring and other representatives of the Nazi regime, were packed back-to-back in Gallery I, as well as art works from Munich's museums and exhibits from the "House of German Art."

The scholarly cooperation between American and German art historians at the CCP was such a success, that Smyth proposed the foundation of an international art history research institute at this location, which was to take on the task of organizing the Collecting Point's infrastructure. Given the prevailing political and economic situation, this seemed to be an unrealizable dream. Surprisingly though, this project was realized with the founding of the Central Institute for Art History (Zentralinstitut für Kunstgeschichte) in November 1946. The organization of this institution was modelled after the German art history research institutions in Rome and Florence. The founding director, Ludwig Heinrich Heydenreich, as well as his colleagues during these early years, Wolfgang Lotz and Otto Lehmann-Brockhaus, had had experience in Italy.

The art historians at the Collecting Point and at the Central Institute for Art History were using the same library and were working in the same building. Some of them knew each other from their shared years of study in Hamburg, Berlin or Göttingen. It seemed only natural that the newly founded research institute's efforts to create an art history community were developed in close collaboration with the Collecting Point. Since the beginning of 1947, academic lectures were held at the library hall of the Collecting Point, taking place in the presence of original art works by Donatello, Renoir or Tizian, whose "Danaë" from the Farnese collection, together with numerous other not less prominent paintings, were awaiting their restitution to the Museo Nazionale

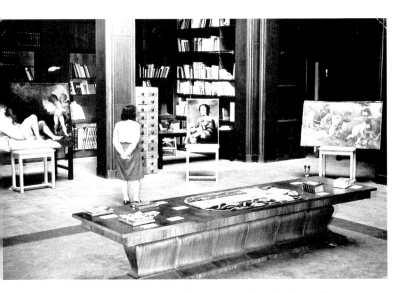

Central Collecting Point, library with exhibit of paintings from the Museo di Capodimonte in Naples (Titian's "Danaë," Bruegel's "The Blind Leading the Blind") and Murillo's "Santa Rufina" (today at the Dallas Meadows Museum), spring 1947

di Capodimonte in Naples (image above). Exhibits with works awaiting repatriation were held starting in 1946.

The mission of the Collecting Point was not yet fulfilled when the American military authorities transferred the responsibility for the safe-guarding and restitution of the looted art to German authorities in September 1949. From 1952 until 1962, the Trust Management of Cultural Property Munich, and later on the regional finance office, were responsible for the remaining inventory at the former Central Collecting Points in Munich and Wiesbaden: particularly returns and cases of unresolved provenance. Today, responsibility for the restitution of art works which already had been classified by the Central Collecting Point as "non-identified property," lies with the Federal Office of Central Services and Unresolved Property Issues in Berlin. In order to advance the identification and restitution of Nazi looted art, an international agreement was reached under the so-called "Washington Principles" in 1998. In a

statement of 1999, the German government, the states and local peak associations committed themselves "to the location and return of cultural assets that had been appropriated through Nazi-persecution, especially Jewish owned assets". Institutions at the federal, state, and local level pursue this mission, among others, the Coordination Centre for Lost Cultural Assets, based in Magdeburg, already in existence since 1994, and since 2007, the Bureau for Provenance Research at the Institute for Museum Research at the Berlin State Museum/Prussian Heritage Foundation. In 2014, the federal government declared the intention of founding a greater German Centre for Lost Cultural Property ("Deutsches Zentrum Kulturverluste").

The »Nazi Monuments« – Temples of Honour

In a telegram to the Office of Military Government for Bavaria, General Eisenhower commanded that the "Nazi monuments" be immediately removed and that the sarcophagi of the 16 "martyrs of the movement" be melted and transferred as metal ingots to a "liberated country" (Eisenhower). The emotionalism of this order reflects – in ideologically reversed terms – the pseudo-religious status of the Nazis' holy shrine at Königsplatz.

Eisenhowers's order was only partly executed because the command had obviously been made without detailed knowledge of the structural conditions of the monuments. A few weeks later, Eisenhower's authorized art official, John Nicholas Brown, visited the site. In light of the art treasures stored in the Gallery I and II and at the urging of the American art protection officers, he decided to forego explosive demolition. The removal of the sarcophagi from the Temples of Honour, however, was executed with an almost pro-grammatic diligence, indicating a sense of concern that these relics could still serve as cult objects. In the beginning of July 1945, the wooden coffins with the mortal remains of the "blood witnesses," which were inside the sarcophagi, were brought back to the grave-sites from which they had been taken before their transfer on November 9, 1935. The corpse of Gauleiter Adolf Wagner who had

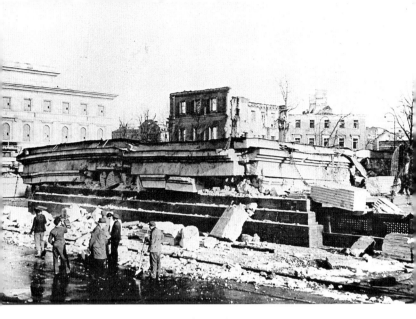

Ruins of the southern Temple of Honour after the detonation on January 16, 1947, in the background the ruins of the Brown House

been entombed east of the northern Temple of Honour was also unearthed and buried in a graveyard. In order to prevent any worship by Nazi followers, the military authorities ordered the material of the sarcophagi – the wooden coffin with the remains of each "martyr" was enclosed within an inner tin sarcophagus and an outer cast iron sarcophagus – as well as each one of the four torch basins from both Temples of Honour to be melted down by a Munich company. The removal of the sarcophagi, "relics" of a quasi-religious Nazi cult, was a symbolic act of denazification with a far-reaching signalling effect. The tin was handed over to the Munich public utility services, who employed it for the production of tin-solder. However, the 453 bars of pig iron, which the Munich public services would have liked to have used for the production of brake pads for the trolley cars, was at first stored at the headquarters of the 3rd US Army in Holbeinstraße. This transfer effectively made obsolete the July 1945 proposal of Munich's mayor Karl Scharnagl to make bells out of the coffins. In the beginning of 1947, shortly before the planned shipment of the bars to Belgium, it was

discovered that most of the bars had been stolen. Hence, the metal was democratically dispersed although not in the way Eisenhower had wished.

The un-demolished Temples of Honour in the former "capital of the movement" still continued to stand as testimony to the Nazi dictatorship. The pillar halls located on one of Munich's most prestigious squares did not fit into the picture of a democratic Free State of Bavaria. However, for the time being, military authorities were too preoccupied with other matters to concern themselves with the Nazi monuments. It was not until spring 1946, that a plan of action was set to remove these "offensive stones." In May, the Allied Control Authority issued Directive No. 30, which aimed to "liquidate German military and national socialist monuments." With a deadline of January 1, 1947, it called for the removal and/or defacing of all "monuments, mementos, statues, buildings, plaques, emblems, street and road signs, [...] which might serve to keep the tradition of the German military alive, to revive militarism or to preserve memory of the National Socialist Party or its Führer." Regarding this ordinance, the designated targets in Munich were not only the many swastikas on building façades but especially the Temples of Honour.

To comply with Directive No. 30, different options for the removal of the temples were possible. Initially, the responsible architect for the military authorities, Dieter Sattler, was afraid that blasting would be too costly and too dangerous for the adjoining buildings as well as for the pipe tunnels which were passing the buildings only a few meter underground, and which were vitally crucial for heating Gallery I and Gallery II. To have the Ferro concrete-constructed foundations of the Temples of Honour removed, would have been too expensive. Therefore, plans for remodelling the sheathing of the existing buildings were developed in the summer of 1946. An extreme example of architectural suppression is the sheathing of the pillar halls in the style of the Rococo Nymphenburg park pavilions (design by Friedrich Hertlein, 1946). For the adjoining terrain along Brienner Sraße, Sattler designed rusticated pavilions and exhibit buildings which echoed a "classical," more precisely, neo Palladian style and plastered the two-story buildings in the tradition of the residences of Carl von Fischer and

Children playing at the foundation of the northern Temple of Honour, 1955

Joseph Höchl, which had been demolished for the Temples of Honour.

In post war discussions about the remodelling of the east end of Königsplatz and Brienner Straße until Karolinenplatz, continuous references were made to the pre-1933 building design. Preference would have been to have this building design brought back as well as have Königsplatz immediately restored to its original condition. Apart from the fact that the large Troost buildings were in use by the Collecting Point and the archives and collections, it would have been technically difficult to demolish them with explosives. However, a concern of all post war plans regarding this area was to terminate the visual connection between the buildings and Königsplatz, with one plan, for example, suggesting the placement of fast growing Lombardi poplars in front of Gallery I and II. Instead, trees were planted on the east side of the square visually to separate the former Nazi buildings from the square.

None of Sattler's architectural designs were executed. Other proposals to set-up cafés or beer gardens in the Temples of Honour, to turn the Temples of Honour into sites of atonement and peace (Mayor Scharnagl) or to establish a Catholic and a Protestant chapel (Cardinal Faulhaber) also attracted little support. Collaboration between the Allies and the Bavarian state government to implement denazification policies repeatedly led to public controversies and political crises. At the end of 1946, a crisis regarding the denazification program came to a head, expressing itself in a contentious atmosphere which also spilled over to the decision about the Temples of Honour. The responsible Bavarian politicians, Prime Minister Hans Ehard and the supervisor responsible for executing Directive No. 30 struggled to prove to the military authorities their willingness to help with denazification and remove any doubts regarding their commitment to the "political clean-up." And thus much public attention came to be focused on the January 9 and January 16, 1947, operations that demolished, respectively, the pillars of the northern and the pillars of the southern Temples of Honour, without damage to adjoining structures (image, p. 81). These measures were undertaken by the construction firm

Königsplatz used as parking area, taken from the south-west, 1987

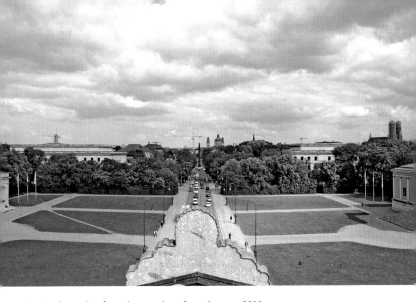

Königsplatz, taken from the propylaea, from the west, 2009

Leonhard Moll, a company which, under the Nazis, had been considerably involved in the remodelling of Königsplatz.

After the ruins had been removed from the temples' foundations and after the stairs had been broken off, clearance of the ruins of the Brown House and the former Palais Degenfeld were considered next. A phase of intense discussion began and continued throughout 1947 over the redesign of the street corners at the intersection of Arcis and Brienner Straße, as well as the stretch between Brienner Straße leading to Karolinenplatz. The fundamental question under discussion was whether to opt for new construction or a green space. The first competition yielded a design by chief building director Karl Hocheder for "new state gallery buildings on Brienner Straße in Munich." Yet again, the building firm Leonhard Moll was involved, beginning construction of a pavilion on the foundation of the northern temple. A 1:1 model of the new building was placed on the foundation of the southern temple, to give the public a chance to see Hocheder's design. Its stylistic resemblance to the preceding Nazi architecture aroused protests from both experts and the public. As a result, the model was removed and construction was abandoned at the end of the year.

In November 1947, a second competition was held, among whose entries were proposals to change Königsplatz into a green space. The competition was focused, however, on the area along Brienner Straße, where buildings for art exhibits were supposed to be built. Martin Elsässer proposed a monumental superstructure on Brienner Straße, Gustav Gsaenger proposed unifying Königsplatz and Karolinenplatz with a continuous promenade and erecting "guilt and atonement fountains" decorated with sculptures on the foundations of the temples reminiscent of Bernini. Taken altogether, the fluctuation between historicizing and modern motifs illustrate the problematic search for an adequate expression of architectural and urban "denazification." As a result, the majority of proposals garnered in the second competition advocated against new construction.

The beginning of this phase of perplexity stands in stark contrast to the decisive, self-confident actions undertaken immediately after the war and clearly demonstrates the advent of a long-standing defensive approach to the Nazi past which sought to avoid a direct and productive confrontation with it. Not knowing what to do with the foundations of the Temples of Honour, these "badges of shame" were quickly fenced in. It was not until the 800th anniversary celebration of the city of Munich in 1958, that complaints about the rotting fence were voiced by the urban reconstruction board. Behind the fence, one saw the corpora delicti, whose interiors had been filled with rubble after it was realized that pools of rainwater could become a danger to the kids who had begun to use the site as a makeshift playground (image, p. 83). After the rubble was removed, the Bavarian State Administration of Castles, Gardens and Lakes planted the foundations with greenery in the winter of 1956/57, without prior public discussion. Since then they have developed into a green habitat used for breeding by rare species of birds and have gained protection as an urban green space. In 1988, a competition was held which focused on the area as a site for new buildings to house the State Museum of Egyptian Art and the University of Music and Performing Arts. However, the competition did not result in any new construction. Since 2001, the foundations of the Temples of Honour, over which a policy of non-action had let "the grass grow," were individually added to the list

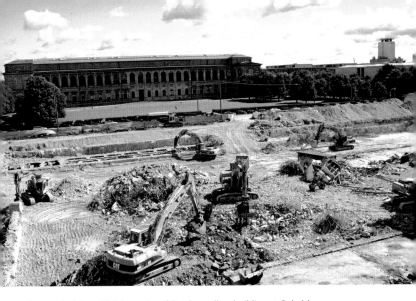

Removal of the edificial remains of the chancellery building at Gabelsberger-straße, construction site for the State Museum of Egyptian Art and the University for Television and Film Munich, 2007

of historical monuments: They have come to signify not only the history of that era in which they were constructed but also the repressed way in which Munich's Nazi past was handled.

In 1987/88, the stone slabs and enclosures of Königsplatz which had been used as a parking area for decades, were removed (image, p. 84). The re-planting of the area in a neo-classical style, as well as the traffic routing, took into account the demands of increased traffic (image, p. 85). In the middle of 2007, at Gabelsbergerstraße across from the Old Pinakothek, the Technical University buildings from the 1960s and the 1970s, as well as the foundations and base-ments of the chancellery building, were demolished. The chancel-lery building had been started in the winter of 1938/39 and was linked via its technical facilities to the other, somewhat older, Nazi buildings on Königsplatz. However, construction had not advanced beyond the sub-levels (image, p. 87). Here, starting in 2008, the new buildings for the State University for Television and Film Munich as well as the State Museum of Egyptian Art (opened in 2013) were built.

In fall 1995, a publication released by the Central Institute for Art History and a photo exhibit located in the northern inner court-yard of the former Administrative Building presented a comprehensive history of the Nazi Party buildings for the first time. With this exhibit in mind, the city of Munich then authorized the architects, Julian Rosenfeldt and Piero Steinle, to set up a display board at the intersection of Brienner Straße and Arcisstraße. This board showed a map of the location as well as information about the National Socialist Party Centre. In 1996, the Maxvorstadt district council requested from the city a permanent historical marker. A revised board composed of durable material was eventually installed, in 2002 (image, p. 89). In fall 2008, after years of debates about the establishment of a Munich Documentation Centre for the History of National Socialism, an architectural competition for new construction at the location of the Brown House on Brienner Straße was launched. In March 2009, a design by the Berliner architecture firm Georg Scheel Wetzel was selected.

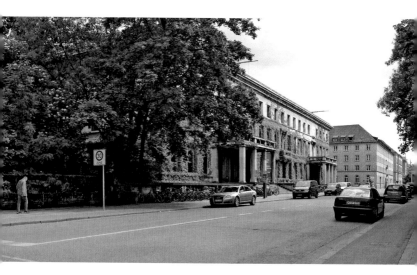

Central Institute for Art History Munich and other Cultural Institutes (former Administrative Building), taken from the north, the former post office building in the background, 2009

*University of Music and Performing Arts Munich (former Führer Building)
and the overgrown foundation of the northern Temple of Honour, in front
the information board, 2009*

By the time of the planned opening of the Munich Documen-
tation Centre for the History of National Socialism in 2015, the
façades of the former Administrative Building of the NSDAP will
presumably be completely overgrown with vines (image, p. 88).
The picturesque impression is the result of a planting initiative in
1990 by the State Building department, explicitly intended to hide
the National Socialist architecture. The change of a former National
Socialist representational building into a fairy tale castle, however,
contradicts the view of the building as a protected historical monu-
ment as well as the long-time educational efforts regarding the
history of the building undertaken by the Central Institute for Art
History.

Klaus Bäumler

THE MUNICH DOCUMENTATION CENTRE FOR THE HISTORY OF NATIONAL SOCIALISM: "MUNICH'S BELATED PATH"

The December 8–9, 2001 edition of the "Neue Züricher Zeitung" includes the following entry: "As birth place and central site of power for the Nazi Party, Munich had played an important role during National Socialist era. However, the Bavarian capital struggles with its "Brown" legacy. While well-attended centres, documenting the Nazi period abound in other places in Bavaria, an interested public in Munich finds hardly any information about the role of the city during the Third Reich." The head line of the article, "Munich's Struggles with the Nazi-Period. Its Historically Repressed Role as 'Capital of the Movement,'" encapsulates the situation in Munich well. The public work of remembrance was especially deficient. This had to do with the fact that for a long time remembrance and commemoration of Nazi victims had been highlighted in Munich. Because of generational change, the psychological barriers to confronting and focusing on perpetrators and sites of crime have increasingly lowered. Munich's responsibility for the rise of Nazi Party hegemony is a central theme for the Munich Documentation Centre for the History of National Socialism. This responsibility has to be accepted by the city of Munich, "because it can never be forgotten, that the brute was able to use this city as a base for his rise to power." (Wilhelm Hausenstein, 1947).

The Documentation Centre came late to Munich, but it did come – through the efforts of a public campaign by Munich's city council, and the Bavarian parliament, who put into motion the rulings of October 16, 2001 and March 23, 2002 respectively. It is worth recording that the initial impulse was given in 1996, by the Maxvorstadt district committee. In November 1996, the citizens committee had applied "to create in the surrounding areas of

90

Königsplatz an institution resembling Berlin's "Topography of Terror" based on the groundwork of the Central Institute of Art History's exhibit, "Bureaucracy and Cult." The city of Munich, the Free State of Bavaria, and the Federal German government ought to sponsor this effort."

After difficult but constructive negotiations, the following plan was carried into effect: The Federal government, the Free State of Bavaria and the city will each take on one third of the overall construction costs (ca. 30 million Euros). Additionally, the Free State of Bavaria provides the building plot, valued at 9 million euro, free of charge, apart from its one-third share of the construction costs. With the resolution of September 18, 2006, the council of ministers followed the lead of the Maxvorstadt district committee.

The competition announced by the city of Munich for the realization of a new building on the plot of the former Brown House (Barlow Palace) was completed in March 2009. The laying of the foundation stone followed on March 9, 2012. The winning design by the Berlin architecture office Georg Scheel Wetzel Architekten creates a deliberate tension with the Troost buildings, in part, by giving the proposed building an independence that consciously breaks with the symmetry of the Nazi architecture. The construction ruins of the former Barlow Palace, exposed during the excavations, testify to the Nazis' early intrusion into the "bourgeois-royal periphery" of the Maxvorstadt. Despite their contemporary importance for the historical authenticity of the location, these ruins were not integrated into the new design.

The content and conception of the Munich Documentation Centre for the History of National Socialism was created through the closely coordinated efforts of the foundation board (led from 2012 by Prof. Dr. Winfried Nerdinger) and the project team (Prof. Dr. Hans Günter Hockerts, Prof. Dr. Marita Krauss, Prof. Dr. Peter Longerich), as well as the academic committee, the board of trustees, and the political committee. It was sponsored by the city of Munich. Taking into account other sites of remembrance (in Dachau, Obersalzberg, Nuremberg, and Flossenbürg), distinctive conceptual focal points were worked out for the documentation centre in order to promote the necessary independence. In this regard, the late realization of this project offers a special opportunity.

It is essential to find answers to the following questions: Why did it happen in Munich? What kind of political and social conditions formed the breeding ground for Nazism's climb to power, for Munich's availability as the "capital of the movement" and "the city of German Art"? How could the Nazi regime in 1933 establish itself within a few weeks in this city without noteworthy resistance from social forces? How did Munich deal with its Nazi past after 1945? What conclusions can be drawn today from this past?

The Munich Documentation Centre's special location, right within the former Nazi Party centre, offers visitors an opportunity to connect visually with the topography, the authentic sites and events which happened in the former Nazi Party district. Special interest should be given to the palatial home of Alfred and Hedwig Pringsheim, the in-laws of Thomas Mann, which was demolished in 1934 for the construction of the Nazis' Administrative Building. The fate of the Pringsheim family and key events in the life of Thomas Mann and his family are in direct historical relationship to the questions of the Nazi documentation centre: Thomas Mann's determined opposition to National Socialism during its rise between the years of 1922 until 1933, his expulsion from Munich and Germany initiated by the "Protest of the Richard Wagner City of Munich" in 1933, his collaboration with children Erika and Klaus in exile, his arguments regarding "inner and outer emigration" after 1945, and his commitment to a more equal relationship between West and East Germany and to a united and peaceful Europe.

The Munich Documentation Centre for the History of National Socialism has a special mission: it is an institution of civic education, not so much a museological site of historical reflection; it is a place that presents information in the service of remembrance and commemoration, a place that encourages adults and youth both now and in the future to be vigilant. It is an authentic place, nestled in today's Maxvorstadt's museum's district, attracting visitors from around the world with an interest in German history. Thus, it is setting an example of how to transcend national borders with a European form of processing past trauma.

Central Institute for Art History and other Cultural Institutes
(former Administrative Building), taken from the northeast, 1995

LITERATURE

Comprehensive, with numerous art historical, historical and essayistic contributions on the history of the NSDAP Centre:

Lauterbach, Iris, Julian Rosefeldt and Piero Steinle (ed.): *Bürokratie und Kult. Das Parteizentrum der NSDAP am Königsplatz in München. Geschichte und Rezeption*, (Veröffentlichungen des Zentralinstituts für Kunstgeschichte in München, vol. 10) Munich/Berlin, 1995. See especially the contributions by Hans Lehmbruch concerning the Königsplatz, by Ulrike Grammbitter concerning the construction history, by Eva von Seckendorff concerning the interior design, and by Iris Lauterbach concerning the post war period, as well as pp. 348–358 for scholarship of sources until 1995.

The files of the denazification court ("Spruchkammer") regarding Leonhard Gall and Gerdy Troost from the Munich city archive have also been analysed for this publication.

Seit 1995 erschienene Literatur:

Altenbuchner, Klaus: "Der Königsplatz in München. Entwürfe von Leo von Klenze bis Paul Ludwig Troost," In: *Oberbayerisches Archiv* 125, pp. 7–126. 2001

Brantl, Sabine. *Haus der Kunst, München: ein Ort und seine Geschichte im Nationalsozialismus.* Munich, 2007.

Grammbitter, Ulrike. "Braunes Haus, München." In: *Historisches Lexikon Bayerns* [2006, URL: http://www.historisches-lexikon-bayerns.de/artikel/artikel_44454].

Grammbitter, Ulrike. "Unbequemlichkeiten der Erinnerung an den National-sozialismus. Münchens Aufarbeitung seiner Zeit als 'Hauptstadt der Bewe-gung'." In: *München – Budapest, Ungarn – Bayern. Festschrift zum 850. Jubiläum der Stadt München*, ed. Gerhard Seewann, József Kovács, (Danubiana Carpa-thica, 2=49), pp. 275–288, 385–397. Munich, 2008.

Hajak, Stefanie, Jürgen Zarusky (ed.). *München und der Nationalsozialismus. Menschen, Orte, Strukturen.* Berlin, 2008.

Heusler, Andreas: *Das Braune Haus: wie München zur »Hauptstadt der Bewegung« wurde.* Munich, 2008.

Köpf, Peter. *Der Königsplatz in München: ein deutscher Ort.* Berlin, 2005.

Krause, Alexander: *Arcisstraße 12. Palais Pringsheim, Führerbau, Amerika-Haus, Hochschule für Musik und Theater.* Munich, 2005.

Lauterbach, Iris (ed.). *Das Zentralinstitut für Kunstgeschichte* (Veröffentlichun-gen des Zentralinstituts für Kunstgeschichte in München, vol. 11). München, 1997.

Lauterbach, Iris. "Die Gründung des Zentralinstituts für Kunstgeschichte." In: *200 Jahre Kunstgeschichte in München. Positionen, Perspektiven, Polemik* (Münchener Universitätsschriften des Instituts für Kunstgeschichte, vol. 2), pp. 168–181, ed. Christian Drude, Hubertus Kohle. Munich/Berlin, 2003.

Lauterbach, Iris. "Das ehemalige Parteizentrum der NSDAP am Königsplatz: ein »Täterort« und seine Wirkung heute. Erwartungen und Profile." In: *Ein NS-Dokumentationszentrum für München*, pp. 232–237, ed. Kulturreferat der-Landeshauptstadt München, editorial department: Angelika Baumann, Klaus Altenbuchner. Munich, 2003.

Regarding the Central Art Collecting Point in Munich:

Lauterbach, Iris. "Der Central Art Collecting Point in München 1945–1949: Kunstschutz, Restitution und Wissenschaft." In: *Raub und Restitution. Kulturgut aus jüdischem Besitz von 1933 bis heute*, pp. 195–201, ed. Inka Bertz, Michael Dorrmann. Göttingen, 2008.

_____. Der Central Collecting Point München. Berlin/Munich, 2015 (in print).

Martynkewicz, Wolfgang. *Salon Deutschland. Geist und Macht 1900–1945.* Berlin: 2009.

Mayer, Hartmut. *Paul Ludwig Troost: »Germanische Tektonik« für München.* Tübingen (et al.), 2007.

Nerdinger, Winfried (ed.). *Ort und Erinnerung: Nationalsozialismus in München.* Salzburg (et al.), 2nd edition, 2006.

Nüßlein, Timo. *Paul Ludwig Troost (1878–1934)* (Hitlers Architekten, Vol. 1). Vienna (et al.), 2012.

Rosenfeld, Gavriel D. *Munich and Memory: Architecture, Monuments, and the Legacy of the Third Reich.* Berkeley (et. al.), 2000.

Seelig, Lorenz. *Die Silbersammlung Alfred Pringsheim.* Riggisberg, 2013.

Images outer front cover page:
Königsplatz and Maxvorstadt towards the east, aerial image, around 1937

Inner front cover page:
Employees of the US-military authorities entering the former Führer Building, 1945/46

DKV-Edition
The NSDAP Centre
published by the Central Institute for Art History

Authors:
Dr. Ulrike Grammbitter, Art historian, Central Institute for Art History, Munich
Prof. Dr. Iris Lauterbach, Art historian, Central Institute for Art History, Munich
Klaus Bäumler, Vice chairman of the political advisory committee of the Munich Documentation Centre for the History of National Socialism, 1978–2008 chairman of the district council Maxvorstadt.

Illustrations:
All images Central Institute for Art History Munich, with the exception of Pages 7, 9, 15, 16, 18, 20, 66: Munich City Archive (Stadtarchiv München) · Pages 11, 54: Private Property · Pages 22, 24, 27, 29: Bavarian State Office for Historical Preservation (Bayerisches Landesamt für Denkmalpflege) · Pages 31, 33, 35, 50, 51, 63, 84, 85, 87–89, 93: Central Institute for Art History (Photo: Margrit Behrens) · Pages 32, 55, 83: Bavarian State Library (Bayerische Staatsbibliothek), Photo Archive Heinrich Hoffmann · Pages 36, 64: National Archives (Bundesarchiv), Berlin · Page 81: Munich City Museum (Münchner Stadtmuseum) (Photo: Walter Francé) · Inner front cover page: Bilderdienst Süddeutscher Verlag

Translation: Julia Schmidt-Pirro, Savannah (USA)
Design, typesetting und layout: Edgar Endl, Deutscher Kunstverlag
Reproductions: Lanarepro, Lana (South Tyrol)
Printing and binding: F&W Mediencenter, Kienberg

Bibliographic information published by the Deutsche Nationalbibliothek
The Deutsche Nationalbibliothek lists this publication in the Deutsche Nationalbibliografie; detailed bibliographic data are available on the Internet at http://dnb.dnb.de

© 2015 Deutscher Kunstverlag GmbH Berlin München
Paul-Lincke-Ufer 34
D-10999 Berlin

www.deutscherkunstverlag.de
ISBN 978-3-422-02400-7

1 Führer Building
2 Administrative Building of the NSDAP
3 Temples of Honour
4 Remodelled Königsplatz
5, 6 Deputy of the Führer and his staff: **5** Brown House (the former Barlow Palace), **6** Former Degenfeld Palace, then papal nunciature
7 Chancellery of the Deputy of the Führer (former Moy Palace)
8 Reich Central Office of the Plenipotentiary for the Four-Year-Plan
9 The Reich Treasurer's Department of Insurance
10 District heating plant, technical facilities and party offices, Administrative and residential buildings of the NSDAP
11 Reich Treasurer's Department of Insurance
12 Main Office V, Reich Treasurer's Legal Department
13 Commission for Economic Policy
14 Reich Student Leadership of the NSDAP, Reich Treasurer's Arbitration Board
15 Reich Propaganda Leadership of the NSDAP
16 Reich Press Office and Foreign Press Office of the NSDAP
17 National Socialist German Student League
18 Reich Youth Leadership of the NSDAP
19 National Socialist German Academic League
20, 21 Reich Leadership of the SS
22 Branch Post Office of the NSDAP
23, 24 Reich Leadership of the NSDAP
25–30 Rented properties of the NSDAP: **27** SA, SS, HJ, Heinrich Hoffmann's photo shop
31 Reich Budget Office of the NSDAP, Reich Leadership of the SS
32–34 Supreme SA-Leadership: **32** former Union Hotel, **34** former Marienbad Hotel
35 The Reich Treasurer's Communications Office, Printing Office of the NSDAP
36 National Socialist Women's League (former Poninsky Palace)
37 Rented property of the NSDAP (former Schrenk-Notzing Palace)
38 The Reich Legal Department of the NSDAP
39 Rented property of the NSDAP
40 The Reich Legal Department of the NSDAP
41 Reich Internal Auditing Department and Reich Financial Accounting Department of the NSDAP (former Lotzbeck Palace)
42 Supreme Court of the NSDAP (former Törring Palace)
43 Reich Organizational Leadership of the NSDAP (former Allianz Building)
44 Chancellery Building of the NSDAP, only basement has been completed
45 Construction Management of the NSDAP
46 Teacher's League of the NSDAP
47 Reich Leadership of the NSDAP
48 Reich Leadership of the NSDAP, Hitler Youth
49, 50 Construction Management of the NSDAP
51 Facilities buildings (bathrooms, first-aid room, phone, microphone and loudspeaker system, press rooms)